# Van Gogh

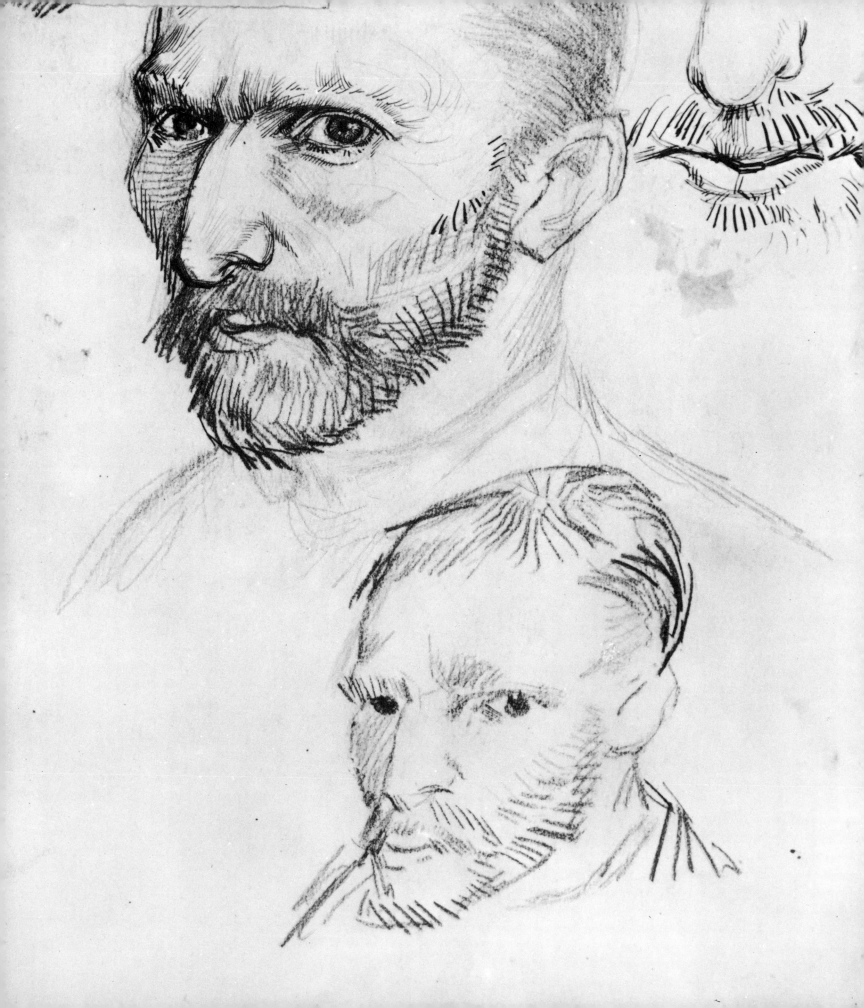

# A.M.Hammacher

# Van Gogh

The Colour Library of Art

**Paul Hamlyn**

London · New York · Sydney · Toronto

# Acknowledgments

The paintings in this volume are reproduced by kind permission of the following collections, galleries and museums to which they belong: Glasgow Art Gallery and Museum, (Plate 12); Courtauld Institute Galleries, London (Plates 25, 36); Gemeentemusea, Amsterdam (Figures 5, 7, 8); Musée du Louvre, Paris (Plates 13, 15, 19, 21, 48); Musée Rodin, Paris (Plates 17, 22, 26); Musées Royaux des Beaux-Arts de Belgique, Brussels (Figure 6); Museu de Arte, São Paulo (Plates 28, 40); Museum Boymans-van Beuningen, Rotterdam (Plates 10, 30); Trustees of the National Gallery, London (Plates 32, 44, 46); Private Collection, Paris (Plate 33); Private Collection, Zurich (Plate 11); Puschkin Museum, Moscow (Plate 42); Rijksmuseum Kröller-Müller, Otterlo (Plates 1, 2, 3, 4, 5, 6, 7, 8, 9, 14, 16, 18, 20, 23, 24, 27, 29, 31, 34, 37, 38, 39, 41, 43, 45, 47; Figures 2, 3, 4, 9); Trustees of the Tate Gallery, London (Plate 35). The following photographs were supplied by Brompton Studio, London (Plate 35); Photographie Giraudon, Paris (Plates 11, 15, 17, 26, 28, 30, 33, 40, 42); Scala, Florence (Plate 21); Service Photographique des Musées Nationaux, Versailles (Plates 13, 19); André Held-Joseph P. Ziolo, Paris (Plate 48). The frontispiece is reproduced by courtesy of the Gemeentemusea, Amsterdam.

First published 1961
Revised edition 1967
Reprinted 1969

Published by the Hamlyn Publishing Group Limited
London · New York · Sydney · Toronto
Hamlyn House, The Centre, Feltham, Middlesex
© Paul Hamlyn 1967
Printed in Italy by Officine Grafiche Arnoldo Mondadori, Verona

# Contents

# Introduction

For those who know Van Gogh the name Auvers, the little French village on the banks of the Oise, evokes unmistakably the image of his early and tragic death. He was there for only two months—from the 21st May to the 29th July 1890.

Of all the periods in his painting life, the time at Auvers is comparable only to that in the Borinage ten years earlier. There, among the miners, the same tensions, the same storms caused by conflicting feelings, had plunged him into deep distress. The absolute solitude of his existence, impelled by a furious creative energy, had even then isolated him from his brother Theo. Van Gogh wrote to him in July 1880: 'To a certain extent you have become a stranger to me.' In the dark night of his distress Vincent questioned whether an existence could become darker or whether it could recover. It was then that his true vocation revealed itself; the awareness of his artistic and creative powers which were from then on irrepressible. The decline of these powers years later was marked by a new solitude, but this time he knew that his creative energies were endangered. Between these two decisive moments he was prey to continual conflicts.

From its beginnings his *œuvre* had shown no hesitation, guided as it was by an intellectual and personal maturity. Van Gogh's beginnings were not those of a young man. The work he produced was old and premeditated. Although limited by too little practical experience, it was created from the first with the force of mature conviction. His art, however, has none of the weariness of the generation that grew up in the *fin de siècle* spirit. The vigour and the sensibility of Van Gogh's works were essentially those of an old rural culture, of domestic life dominated by women: his universe was determined by matriarchal control in which the thatched cottage and the hearth formed the central points of attraction. The field awakened in him the instincts of agricultural labour, in which, moreover, the Brabant women played an important part.

His attitude towards animals is likewise proof of the rural spirit in Van Gogh. Undomesticated animals have little place in his work. If he identifies himself with any animal it is with the dog that is continually turned away, or with the worn-out cart-horse.

In the most important of his Brabant canvases, *The Potato Eaters* (plate 3), it is the triangle of women that dominates the composition, the youngest being placed in the foreground and almost in the centre. While Van Gogh was in the Borinage, he was no less interested in the women than in the miners themselves, and this is true of the work he did at The Hague and in Brabant. Throughout his life woman was dominant. Van Gogh underlined this predilection by adopting the convinctions of the historian Michelet on the position and value of women and on the feminine element in life. These matriarchal tendencies removed from his apparently disturbed existence the truly vagrant character. Van Gogh dreamt not only of a well ordered personal life but also of a future organisation of art and society. He was a Utopian who, in a society dominated by women, wished to concentrate order around the hearth. He once described artists as the great lovers of an order and symmetry which nevertheless they could not realise in the social conditions of his time. He was not a pariah out of conviction, but in spite of himself.

After the Dutch period Van Gogh's work is distinguished by two essentially contradictory tendencies, which he was never able to reconcile and which reasserted themselves in the south in another form. The art of the Dutch interior in which he began was moderately Impressionistic and entirely in conformity with the liberal bourgeois atmosphere of the period—intimate, restrained, sensitive and without any feeling for revolt. Its nature still contained much of the quiet art of the eighteenth century that Van Gogh admired so much in Chardin. Although Van Gogh disliked the bourgeoisie, he

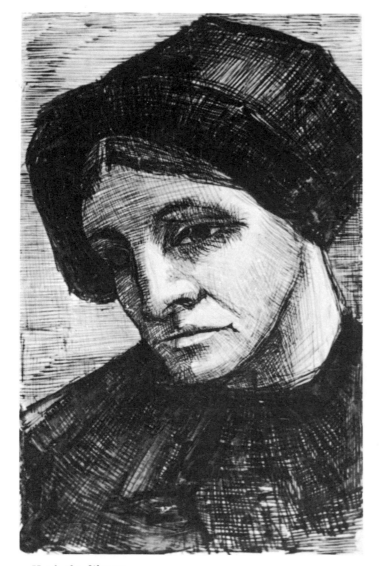

2 Head of a Woman

did not reject this art so long as its themes centred round the people and the simple rural life.

But diametrically opposed to this was his need to express himself in colour and his refusal, following the example of Delacroix, his favourite model, to use contours as a point of departure. The expressionist rendering of *The Potato Eaters* is a compromise. The painter, on the one hand, shows signs of an expressive realism close to distortion and based primarily on colour, whilst on the other hand he preserves the epic interior motifs in the style of De Groux—not in the soft atmosphere of the Hague School, but in its primitive depiction of an almost animal existence. In fact the heads of the potato eaters painted at this time reveal his strength better than does the composition of the group.

Following Van Gogh's development in Antwerp and afterwards in Paris, one sees his work brightening and becoming much more youthful than one would have thought possible to judge by his Brabant paintings. The fusion of graphic and pictorial elements in his technique enabled him to work in a style that was more agile, nervous and less heavy than before. Paris marks a period of expansion; Van Gogh avidly collected influences without, however, losing himself in them. He persisted less in single themes than he had done in Brabant with rural life. The opposition of the two forces which gives his Brabant works such a tense and laborious character seemed to disappear in Paris both in the themes and in his treatment of them. In fact the expressionist tendencies that were displayed in Brabant with such rebellious assurance (for example, in his argument with Van Rappard), are here considerably weakened or relegated to secondary importance.

But why then did he go to live in the Midi? What did he expect from this southern landscape? As always with Van Gogh there is a complexity of motives. In Theo's eyes his departure for Arles appeared like flight. Life together had done him no good. Both had passionate characters. Vincent

felt his energies decreasing and feared a nervous depression. The large city oppressed him. He missed the sun, both physically and mentally. His love of Japanese art, which others, long before him, had cultivated for artistic reasons, became in him no less an ethical problem. He wanted to exploit its richness of colour, which had become almost impossible for him in Paris. The intensity of colour he had experimented with in Brabant was translated under the influence of Paris into a light palette without bitumen or shadows. It was, so to speak, called to order and it was this so much desired order that suppressed it. The old Brabant tendencies came into their own again. That is why he could justify his departure for reasons of an artistic and technical order. At first Arles seemed to satisfy his desires, partly because the little town reminded him of similar towns in Brabant, such as Breda; partly also because in his hours of exultation he saw there the realisation of his image of Japan. The fusion of graphic and pictorial elements effected in Paris persisted for some time at Arles, finally only to collapse: nevertheless the two elements gained by it.

In Arles, before Gauguin's arrival, Vincent achieved what he had not succeeded in achieving either in Brabant or in Paris, namely a synthesis of his conflicting tendencies. In Brabant the sombre expressionism of colour had led him to distortion. In Paris he had abandoned this path. His palette had lightened, but in the motifs he had begun nothing that allowed him to penetrate to the essentials at the expense of natural appearances. But in Arles, where the atmosphere of the little provincial town and of the countryside reminded him of his past, the vigour of his colour regained the upper hand. Even his adoration of rural life and of maternity were reinforced by his contacts with the family of the postman Roulin.

His sense of form and his mastery of perspective were accentuated, albeit temporarily. His excitable temperament

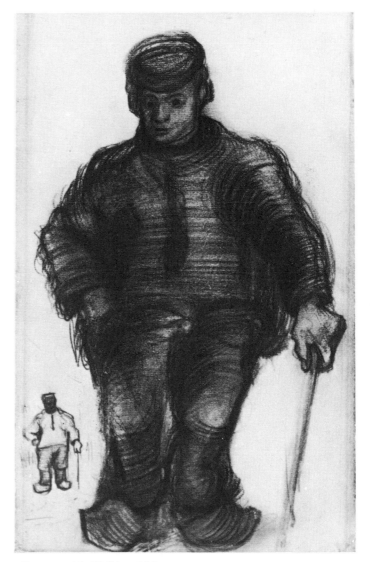

3 Peasant with Walking Stick

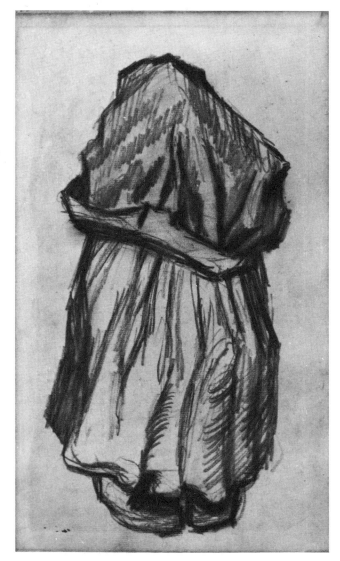

4 Peasant Woman with Shawl

and his expressionist sense of colour (ever more accentuated since his stay in The Hague) never allowed him to construct his spatial vision from any one fixed point. That is why, after his period in The Hague, he worked with a perspective frame that he had designed himself, in order to obtain more expression in his perspective. In Arles he was able, to his great delight, to dispense with this instrument, for here more than anywhere else his expressionism found a fixed point. Thus he saw with delight that he was acquiring assurance and equilibrium.

Does this mean that at this time Van Gogh was becoming classical? To a certain degree, yes.

Temporarily he became classical, though more in appearance than in reality, for he lacked that instinctive objectivity that separates the truly classical artist from the thing observed. The classical artist, having observed and measured his observations, puts them in order and ascertains reasonably enough that subject and object are two separate things. Van Gogh, on the other hand, makes no distinction between subject and object. His use of colour is too intense and his lines too charged with inner tension, so that in fact all distance is abolished. He does not see only the Pont de l'Anglois at Arles but *is* himself this little bridge, as he is also the blue sky behind it and water beneath it. The picture represents not only the little bridge, but also at the same time the painter himself, who in the south was unable to forget the north where he had long known such a bridge on his daily walks in Brabant.

Van Gogh is himself this bridge, which wishes to fill in a gap, an isolation, which dreams of uniting on earth the towns with the countryside, and also the earth with the stars—a union that can be realised only through death. To go for walks, to cross the bridges, signs of long voyages, all this was for him heavy with meaning.

The feminine element began to assert itself in Arles in the

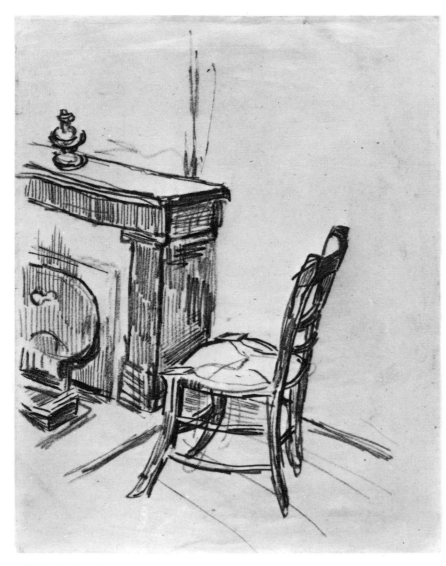

5  Chair  by  the  Stove

*Berceuse*, a restful image of maternity. The *Berceuse* is a closed motif, treated in a dual fashion; that is to say the style of the upper part is sharply distinguished from that of the lower. The contours and the undefined areas of colour clash with each other. The little bridge, on the other hand, which is an open motif, symbolises the male element, the man's gait, which means the abandoning of the fireside, of the established order, of regular work, of family life, in short, the abandonment of 'order and symmetry', things which Van Gogh in his innermost being nevertheless felt to be very desirable. There is in this painting a conception as far removed from the classical as possible, a passionate communion which primarily is not reasonable. It is that of the whole man who abandons himself to observation, penetrating to the roots of things. This vision of the world which Van Gogh conceived at Arles is complex. It is the triumph of the Japanese exultation, though he never abandoned the northern landscape motifs. The bridge, the plain of La Crau, the willows—'all that', he wrote, 'makes one think too much of Holland.'

Was this realism, permeated by subjectivity, something new in European art of the nineteenth century? One would think so; for if not, how are we to explain the fact that the yellow and blue *Pont de l'Anglois* (plate 23) cannot stand any other contemporary painting at its side? It is not distinguished by distortion; on the contrary, there is nothing hasty about its touch, which is nowhere obtrusive, and nothing unpremeditated in its colour, which is simple. One might say that this is the work of a tamed, but not a captive, Van Gogh.

What is enigmatic is that the distance between the 'I' and the 'world' is abolished; a distance that neither Poussin nor Corot nor any other classically inspired painter had crossed with such boldness as Van Gogh. He himself penetrated into the thing observed and was lost in it. Only spatial perspective ensured visual order. This idea of space overcome, that is to say, the abolition of the distance between subject and object,

evokes for me the death force latent in Van Gogh. He had the serenity of those who, being ready for death, recognise the radiance of life. From this time on he was in fact capable of this movement of soul, of this *transport* which he evoked so curiously by asking if one could travel to the stars. *Transport*, to be transported, presupposes that one has the faculty of overcoming distances and of identifying oneself with them, of surrendering oneself body and soul, which is neither classical nor reasonable. He who surrenders himself, refusing to be held back by limits, penetrating into things in order to surprise their secret, risks losing himself. The classical man, however, wisely stops at the surface of things, in front of their limits, knowing or assuming that behind them lies the impenetrable, unknowable secret from which men are always separated.

Van Gogh's realism at Arles seems then to be an apparent classicism. His ineradicable conviction that the reality of his creations is identical with the thing seen introduces for the first time in the art of the nineteenth century an element that one can compare only to the magic realism of, for example, Negro art. Van Gogh believed fanatically that he could make, not a representation of appearances (the symbolism of Gauguin and Bernard left him cold), but the essence of reality in the image. This conviction was not of a religious nature but magical-realist and expressive. (Van Gogh did not formulate it very consciously and certainly insisted on it less than I do, but he was nevertheless very near to this formulation.) Thus this apparently classical character, which Van Gogh's work at Arles presents up to the time of his mental breakdown and Gauguin's departure, was in fact an expressive serenity, a more-than-limpidity. This quality sometimes falls to the lot of beings whose exceptional sensitivity and great talent assure the maximum effect for their gifts of observation.

During the summer of 1889 at Saint-Rémy important changes took place. His sister-in-law, Theo's young wife,

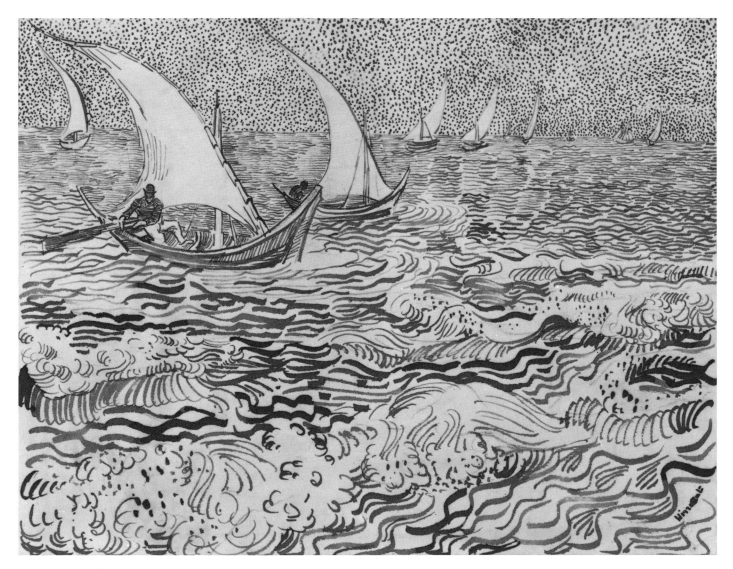

6 Boats on the Sea at Saintes-Maries-de-la-Mer

told him of her pregnancy in July 1889. This must have moved him deeply. Vincent reacted immediately to this 'great news' as he called it. In her reply to his letter there is also a curious passage on 'restraint', which made him feel rather as he had felt 'when he was much younger, when he too was very restrained, too much so, it was said.' He then said that deliberate restraint leads to a state of mind where he begins to 'paint grey.' 'In fact I am becoming a greyer painter,' he discovers. Painting grey was not solely an aesthetic question with Van Gogh but also a turning point, a physical change, indicating abstinence, which exercised considerable influence on his art. One can follow the subsequent process step by step.

He wrote at the same time to his mother, saying that 'our cultivated fields in the north are infinitely pleasanter and more regular than those in the south, where the soil, due to its rocky nature, does not lend itself to all sorts of agriculture.' He wanted to paint buckwheat, blossoming cole-seed or flax. Likewise he missed the moss covered roofs of the Brabant farms. Apparently he wanted to excuse himself to his mother for having gone to the south. Despite his Japanese vision he preferred Dutch-style motifs even at Arles, where, however, the intensity of colour and the joy that the southern heat gave him were predominant. But at Saint-Rémy, in the summer and autumn of 1889, memories of the north, above all memories of Brabant, of the heather in the Campine and of Antwerp, came to his mind. He hesitated. After a new crisis, which seized him while he was painting in the fields, he wrote that at some moments he felt he would like to begin again with a palette, 'such as I had had in the north'. In this period the south is struggling with the north. He had not yet completely surrendered. The situation only became serious in August 1890 when he wrote: 'If with the experience that I have at present it were possible for me to begin again, I should not go exploring in the south.' In other words, he no longer regarded the experience of the south as essential or indispensable. In his heart he had detached himself from it. The great fascination of the south and everything connected with it, such as the adoration of Japan, began to recede.

Nevertheless he felt unhappily that a new affection had been born in him, for men above all and for things. His complaint is like that of a wounded man who knows that he is doomed when he writes: 'Ah, my dear brother, that heather of the Campine, that is something now.' The cries of the storks, he says in another letter, suggested to him the crickets on the hearths of Brabant cottages. While wishing to escape to the hospital of Saint-Rémy, he also thought of leaving the south, and now and then of staying in Paris or at Pont-Aven in Brittany in order to get nearer to the north. He had crises of uncertainty and irresolution: he began to realise what it meant to separate himself from the south. The north appeared quite new, but he had observed things so well and was so deeply attached to them that a deep melancholy took possession of him. Remembering his Belgian experiences, he spoke, in describing his great nostalgia, of being 'homesick as a Swiss'. The heather of the Campine and of Brabant had been abandoned by the Van Gogh family since his mother had moved house, and this thought was painful for him.

The struggle continued. He began to explain why his work needed the south, but he who has to explain his love has already lost it. Van Gogh was not even sure that he still needed it. He began to give technical reasons for his love. In the northerner the great enthusiasm for the south had ended by giving way to a feeling of defeat. He wished indeed to return north, but provisionally. He asked Theo to send him his old sketches; he wished to work from memory after northern themes, even to remake *The Potato Eaters*, *The Tower at Nuenen* (plate 7) and *The Thatched Cottage*. Sometimes his palette became strangely silvered, ash grey, perhaps the

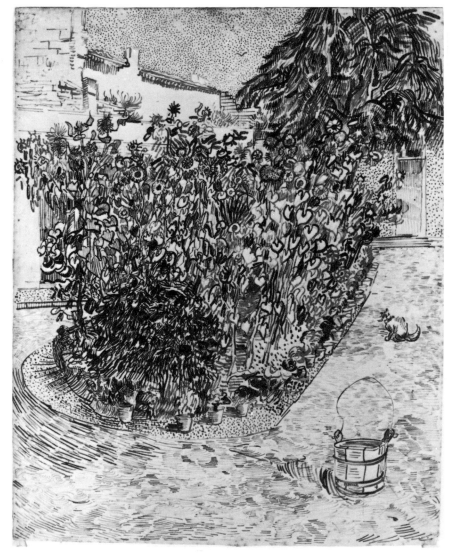

7 Flower Bed

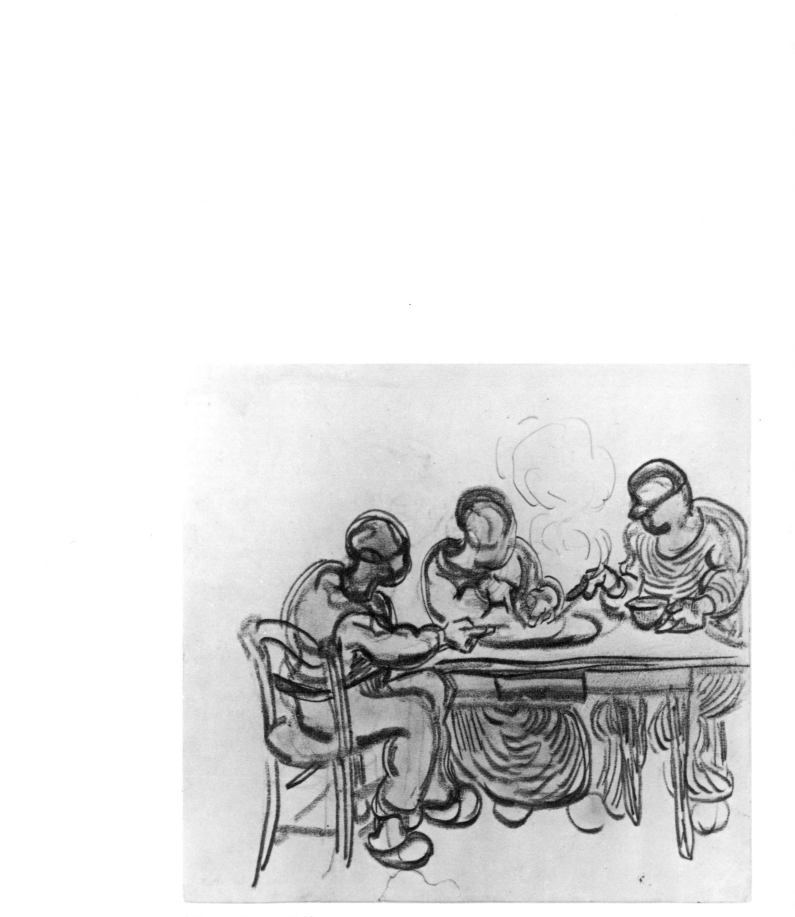

8 Peasants Seated at Table

glow of his memories of Brabant and the Campine seen from afar.

The thought of returning to the north which he had to reconquer, had far-reaching consequences in his artistic orientation. We know that Van Gogh thought very highly of Delacroix's art. But another artist, who has been ignored by Van Gogh's commentators up to now, became the object of his admiration, namely Puvis de Chavannes. Critics of modern art, enthusiastic about Van Gogh as the father of Expressionism and Fauvism, easily overlook Puvis who does not suit the impetuous temperaments of today.

Who indeed would ever have thought of researching into the contacts between Van Gogh and Puvis de Chavannes? This painter of pale frescoes, who rejected all Impressionism, realised his Greek dream and his cult of Giotto in unreal landscapes and idyllic human figures which astonished the nineteenth century. Artists such as Gauguin, and later Denis Maillol, had a great respect for Puvis.

We realise the complex character of the Arles period once more when we learn that in 1888 Van Gogh described Puvis' *Saint John the Baptist* as —'amazing' and 'as magical as Delacroix'. But we do not yet know what influence Puvis was to have on him as a result. He also knew Puvis's *Hope*, which Gauguin admired so much that he included it in one of his own works. Van Gogh saw it as a beautiful and youthful picture of, above all, serenity. In the Greek character of a town like Arles he rediscovered Puvis de Chavannes, and often the landscapes of the south were to remind him of beautiful pictures by this painter. After his mental breakdown at Arles he wrote about a doctor who had some ideas about Delacroix and Puvis. After that he quoted both of them.

Arles also inspired him with Italian fantasies—imaginary, it is true, for he had never seen Italy. His reading about Dante, Giotto, Botticelli, Petrarch and Boccaccio provoked dreams, but it was Giotto who most affected him. Giotto, ever suf-

fering, whom he was later to call 'the great sufferer', was for Van Gogh a contemporary. He described him as suffering but nonetheless capable of being 'full of kindness and warmth, as if he already lived in another world than this'. He who can thus characterise Giotto without ever having seen Italy may well possess this powerful lucidity of which I have already spoken in connection with Arles—a need of *transport*, of escape to the stars far away from this life. During his stay at Arles he sometimes went to Saintes-Maries-de-la-Mer. The young girls of Saintes-Marie reminded him of those of Giotto and Cimabue, so slender, so upright, rather sad and mysterious. In the museum at Montpellier he had seen with Gauguin a small painting by Giotto representing the death of a saint. The expression of this woman was so unhappy and yet so ecstatic and human that Van Gogh felt this emotion as a contemporary. At Saint-Rémy this love for Giotto increased. He wrote: 'If I had the time to travel I should like to copy the work of Giotto, this painter who would be as modern as Delacroix if he were not primitive and yet so different from the other primitives.'

Even when discussing a portrait by Rembrandt, he said that Giotto formed a possible link between the school of Rembrandt and the Italians. The splendour of Japanese art that Van Gogh had at first found at Arles came to oppose the figure of Giotto, so fine, so discreet, a touch of grey among the burning fires of the south.

Then there is the figure of Puvis de Chavannes who from then onwards joined that of Giotto. In December 1889 he wrote: 'The portraits by Puvis de Chavannes of an old man reading a yellow novel with a rose at his side and water-colour brushes in a glass of water, and of a woman who is already old, but just in the way Michelet felt it, that there are no old women—these have always remained ideal figures for me.' He considered Puvis and Delacroix healthier than the Pre-Raphaelites.

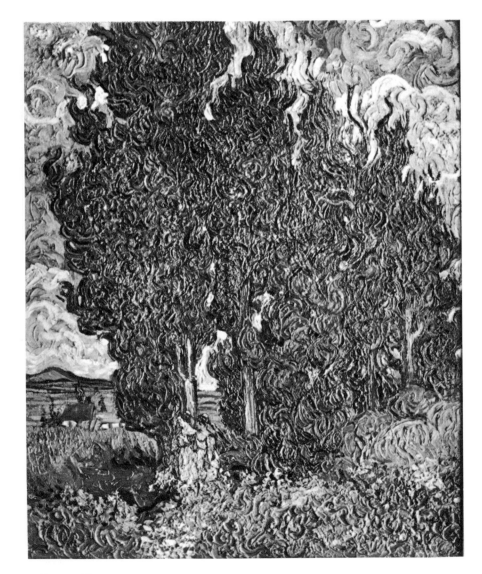

9 Cypress Trees

This portrait of a woman could only have been that of the princess of Cantacuzène, Puvis's friend and later his wife. The painting is at present in Lyons.

At Saint-Rémy Van Gogh heard an intimate and ancient murmur in the noise of the olive trees: he saw the oleanders and they reminded him of the women on the seashore painted by Puvis, a picture entitled *Le Lesbos*. Puvis de Chavannes was 'consolation, calm and serenity'. From this time on this painter was continually present in Van Gogh's mind as he made his way northwards to Paris and Auvers.

The publication of Van Gogh's letters contains a curious letter addressed to the painter and critic Isaacson, written no doubt in Paris in 1890 when Van Gogh was on his way to Auvers (see page 00). This letter, like another sent to his sister, confirms the great importance Van Gogh attached to Puvis, who had become as important to him as Delacroix. Why? Van Gogh explained it in great detail. In Puvis he saw the meeting of past and present. In his work the past had Greek perspectives which did not allow one to distinguish exactly whether the clothes of the persons depicted were ancient or modern. In Paris Van Gogh had in fact seen paintings by Puvis in a salon on the Champ de Mars (in the spring of 1890). In a letter to his sister he expatiated on one of the pictures that inspired him with complex and majestic thoughts. He was no doubt referring to the large canvas called *Between Nature and Art* intended for the city of Rouen.

The large theme of olive trees and the olive harvest (in the eyes of Van Gogh a religious theme which united the most distant antiquity with modern times) would, he thought, be very suitable for Puvis, to whom he even attributed visionary qualities.

The two contradictory forces in Van Gogh mentioned above became 'the past' and 'the present' which he now tried to reconcile. And in the end the name of Giotto returned to him, evoked intuitively no doubt by Puvis de Chavannes.

This fits in moreover with the influence that Giotto exercised at that time on the revival of rural painting, and in particular on the artists of 'Art Nouveau'. For Van Gogh, Giotto, the 'great sufferer', was as familiar as a contemporary.

In Puvis de Chavannes he felt this vague modernity of an art which looks for the architectural element, the unity of style, the universality of man and his dignity; an art which is opposed to Impressionism. At times pastoral, this art nevertheless deepens to the point of becoming elegiac. This explains how Van Gogh, rejecting at this point the ideals of Bernard and Gauguin, discovered the origins of 'Art Nouveau' and related them to his own style. Indeed, in the wavy lines of some drawings dating from Saint-Rémy and of some paintings from Auvers, this influence seems clearly visible.

The decline in his critical faculties, which could now place Puvis de Chavannes alongside Giotto on a par with Delacroix, can only be explained by a change which took place in Van Gogh's whole psychological and artistic being. This change was manifested in his return to the north, the need for which he had already foreseen at Arles and Saint-Rémy, and that at Auvers was in the process of being realised. The south lost its attractiveness for him and the north represented a regressive movement towards youth, but also towards the unstable perspective.

The period of return, prepared for at Saint-Rémy, took place between July 1889, when he began clearly to be aware of it himself, albeit hesitantly, and December of the same year. The works produced during this period are of very unequal quality.

But although taken as a whole one cannot speak of an improvement in the quality of his work, Van Gogh produced some of his major achievements at this time; pictures remarkable for their intensity of colour and the significant lack of balance in his vision of space, for instance, the *Church*

*at Auvers* (plate 48), the last known self-portrait, dating from Saint-Rémy, the two portraits after Dr Gachet, however unequal, all the repeated or copied motifs and some landscapes. Another canvas showing two young children against the background of a cottage, of which two copies of unequal value are in existence, exemplifies the technique of linear contours which opposed that of Delacroix, according to which one should start from the interior and end simply in the outlines. The children seem to be seated, but, as in the portrait of Gachet in the Louvre, there is no precision of attitude in space, and the face and hands are weakly modelled.

The painting of a bouquet of roses and anemones in a vase reveals the same uncertainty as to perspective as the portrait of Gachet in the Louvre. The point of view controlling the perspective is uncertain. The vase is placed across space because the bunch of flowers and the vase itself occupy a position which is badly determined and badly balanced in regard to the slope of the table.

Dr Gachet's garden contains the same shades of red and blue as those which were used for his portrait.

The canvas representing Mlle Gachet in the garden is an astonishing work. It was with reference to this canvas that Van Gogh said he had discovered the grace of the picture by Puvis de Chavannes entitled *Between Nature and Art*. Mlle Gachet's long white silhouette makes one think of a phantom whose sinuous lines, in 'Art Nouveau' fashion, seem to hover among the pale flowers. No path can be seen; a little gate is vaguely suggested in the distance, whose chaotic blotches of colour make an undulating impression due to the spirals and the dazzling lightning strokes.

Thus the Auvers period reveals a series of works which have this in common: that their points of departure and of perspective have become uncertain. The perspective that Van Gogh was previously so concerned to control escapes his will. The very intense colouring, now become greyish and now with a quite new vividness, is *ordered no longer for its spatial effect but for its expressiveness.*

Van Gogh's work reveals at this stage a certain preference for the oblong form, perhaps under the influence of Puvis de Chavannes. This format permitted two different spatial centres on the same canvas, thus fitting in with the uncertainty of his perspective technique.

From the psychological point of view his evolution towards Puvis and Giotto is equally explicable. Far from bringing him joy, the open country frightened him. From the time of his mental breakdown, the landscape around him served simply to accentuate his solitude. At one time the cornfields had been his refuge, his consolation. They had taken the place of wife and family and had illumined things which were often obscure in his life. The field and the corn, the ripening, the harvest, the bread-making, all these things had revealed to him the meaning of life consecrated to death, and then had been reassuring, as if the discovery of a sublime law had reconciled him to his fate.

From then on Van Gogh turned to the old moss-covered roofs. He had missed them in the south and was happy to find them again at Auvers. But why? Because then he loved what was *old* and reminded him of the warmth of the past. The old church at Auvers is that of Nuenen, but more sumptuous, more expressive in its colour. But the word *old* also suggested suffering, disease, ugliness and poverty. The moss and the ivy, loved old things, felt attached to them, attracted to them as the cancerous tumours that lovingly attach themselves to men. He felt himself to be ill with cancer. The moss, the ivy, the old roof, these were all symbols of the forces which were developing within him.

In Van Gogh's return, it was the old life that took the upper hand, the north, the memories, the desire for refuge and for the family he had not been able to found. He was defeated by the old life as old roofs are defeated by the moss.

The north of his memories attached itself to him, loving him and at the same time killing him. Van Gogh's return was not a triumphal march. For a long time he had been struggling with the idea of suicide. He had long known that he was not a hero and that too often he lacked courage. Sometimes he did not even dare to go out of doors for fear that something might surprise him in the field when he was wrapped in solitude. What happened at Auvers had already been proclaimed in the letters from Arles and Saint-Rémy. He knew that in time he was going to succumb to the suffering that still awaited him. 'I am not courageous', he said, 'nor patient.' Why then attribute to him qualities that he, with more insight than we, knew himself to lack? With our tendency to see things in too rosy and romantic a light we are too often inaccurate.

He never again saw the true north, the Brabant of his dreams, the heather of the Campine. On the way back, Auvers was the halt where his old dream, in which man was able to take the train of death to reach the stars, became the terrible reality. At last he had broken the closed circle, which in his drawings and paintings had already become spiral. The several climaxes of his work at Auvers were sacrifices in the literal sense of the word. There the whole of his exhausted and shrivelled life disappeared in the most sinister and menacing blue ever painted.

# Biographical outline

**1853** Vincent Willem Van Gogh is born on the 30th March, 1853, at Groot Zundert in the Dutch province of Noord Brabant, th second child of that name, the first having been still-born.

His father, Theodorus Van Gogh, was a clergyman; his mother's name was Anna Cornelia Carbentus. Four years later Theo, who was to give his brother great moral and financial support, is born in Zundert.

**1864** Vincent goes to an institute at Zevenbergen where he receives his education for four years. His first artistic impressions are gained in the neighbourhood from an uncle, Vincent, who was an art dealer at Prinsenhage.

He starts drawing early and many of his childhood drawings from 1863 onward are extant (studied by Professor Dr J. G. van Gelder and very worth while investigating in connection with his later development).

**1868** Vincent returns from Tilburg to Zundert and a year later starts as an apprentice in the art dealer's firm of Goupil in The Hague: five years later his brother Theo receives a similar training while Vincent is transferred to Goupil's London branch (1873-74).

**1873 -74** In London the shock of an unrequited first love for Ursula Loyer, the daughter of his landlord, produces the first violent inner crisis. Van Gogh turns away from the world in a burst of nervous religious enthusiasm. He neglects his work; his disapproval of art dealing increases once he is transferred to Paris. His interest in literature, religion and art grows, but at the same time contact with his immediate environment becomes more difficult.

**1876 -79** After having been sent back to London for a short period, he returns briefly to Goupil in Paris, but is dismissed in 1876. The study of the Bible then becomes his main preoccupation.

There follows a series of five unsuccessful attempts to achieve something in society along the lines of his religious desires: Ramsgate, April—June, assistant teacher at Mr Stoke's boarding school; 10th December, 1876, at Mr Jones' school in Isleworth; in Etten with his parents throughout January 1877, and then assistant in a Dordrecht bookshop until May 1877. By studying Greek and Latin he tries to gain admittance to the university in Amsterdam in order to become a preacher, but this is beyond his powers, and in 1878, as an assistant evangelist in the Borinage (a mining district near Mons in Belgium), he attempts, in accordance with the teachings of the Gospel, to do something by means of active help and advice within the poverty-stricken mining community. He does not get a permanent appointment.

His behaviour is considered extravagant, judged by the norms of the community. He antagonises everyone by the uncompromising nature of his convictions and his actions. His reading of Michelet, Beecher Stowe, Hugo, Dickens, etc., and his interest in art, are extremely intense. He makes sharp criticism of social morality and customs, even in church life, and does not exempt his parental home from these attacks.

**1880** This year is the great turning point of his life. He becomes aware of his creative powers and in the extremes of inner need, deserted by everything, his calling as an artist wins through in the Borinage. Out of a religious tension a creative tension is born. Being an artist in the nineteenth century no longer implied any significant

social attachments. Nevertheless art has a task to fulfil in life and even without academic training Vincent prepares himself for this task. The whole man already speaks to us. The vast and impressive correspondence (mainly with Theo and his sister Willemien; later with his artist friends Van Rappard, Bernard and Gauguin) begins as early as 1872, and by 1880 is already copious.

Vincent now wants to learn everything—perspective, anatomy, above all, drawing and after that, colouring. He has respect for craftsmanship, but rebels against the loss of character involved in conforming to academic or social standards. His relations with his parents, with whom he stays in 1881 on his return, without funds, from Brussels, are made difficult by his critical and asocial attitude. Everything becomes even more difficult when a violent and impossible love for a widow with a small child, his niece Kee Vos, once again brings home to him the intolerable position in a bourgeois society of an artist without private means.

**1881 -83** He experiences all this at first hand and breaks away intellectually from his father's ideas on the Church and on religion, only to be frustrated in his veneration for the masters of the Hague School (Mauve, Israëls, Weissenbruch) by a conflict with Mauve, his tutor in The Hague, where he has been staying. He wants to learn, but at the same time not abandon his own already matured opinions. He is not accepted into the painter's circles but remains living on the periphery. His living with a pregnant woman, Christine Hoornik, has about it something defiant and at the same time consoling after his previous failures. House and home mean much to him. After breaking with Christine in 1883 and leaving for the province of Drenthe he never again has an intimate relationship of any significance with a woman. This remains to the last his great lack, for essentially he seeks order and a centre.

**1883 -86** After Drenthe he returns in 1883 to his parents at Nuenen (Noord Brabant) despite the strain in his relationship with them. He now realises dark landscapes and scenes of peasant life; a sort of heroic poem in which he is in fact already unconsciously practising Expressionism by stressing character and expression rather than perspectival and anatomical accuracy, which even Impressionism had left intact. His powers as a painter are already very great. His artistic credo is expressed in its full range. He throws his whole being into his painting and concentrates, above all, on the great and profound vision of working and suffering mankind. He thrusts aside the bourgeois code of beauty and instead accentuates the ugly, the hard, the angular, so long as these have genuine and deep life and bear the marks of pain and suffering. He is inspired by Delacroix's theory of drawing and of the autonomous value of colour, while his reading of Zola affects the content of his work.

**1886** This is the year in which he leaves his native land and his parental home forever (his father having died suddenly at Nuenen in 1885). He travels via Antwerp to Paris. Antwerp fascinates him: he discovers Rubens, and the Japanese woodcut begins to exert a conscious influence on his view of life. Conflict with academic standards is inevitable. In March 1886 he stays with his brother, who is manager of the modern department of an art dealer's where he tries to sell the not-yet-accepted impressionists. Van Gogh's palette becomes lighter in two stages. In the third stage it is the examples

of Signac and Seurat which wholly change his Dutch palette. Paris is for him an exciting city where the strong motifs of peasant life and the countryside give way to lighter subjects—still lifes, flower pieces, restaurant interiors, portraits, the banks of the Seine, gardens and a remarkable series of small self-portrait studies. He comes into contact with Toulouse-Lautrec, Guillaumin, Bernard, Laval, Anquetin, Gauguin, Russell, Reid and the Pissarros (father and son Lucien).

Japan in all its aspects continues to fascinate him; so much so that even his vision of Japanese life is coloured by it. As his correspondence with Theo ceases, since they are living together—which, incidentally, proves a great strain—and as we thus have to rely on only a few letters sent to other people, we know relatively little about his time in Paris. His work has become lighter, more nervous, and extremely sensitive to influences, but always recognisable from the unsystematic nature of his technique.

**1888** Rather suddenly, in February, Vincent leaves for Arles in Provence: we do not know why. He is obviously fleeing from the city and his brother's milieu. He wants to be in a small town and in the countryside again. Moreover he finds 'Japan' in Provence and wants to establish a centre of his own again, an artists' centre— La Maison Jaune.

He believes in the significance of Provence for the new painters. Gauguin he insists must come, but Gauguin cannot and will not until Theo manages to provide him with the money for the journey. The sun becomes his symbol. But gradually there evolves an almost romantic longing for the moon and the night. Even before Gauguin arrives on the 20th October, Vincent is already unbalanced. The Japanese vision is sometimes interwoven with a vision of the ancient and Italian elements in Provence. Names never mentioned by him before, such as Petrarch, Boccaccio, Dante, Giotto and Cimabue, come to people his imagination.

His longing for domesticity is partially satisfied by his friendship with the family of Roulin, the postman. His relationship with Gauguin deteriorates: Gauguin is domineering, and Vincent, who greatly respects him, finds his pressure restricting. They visit Montpellier in December. There their points of view and insights clash. Vincent regains his independence but only after a loss of self-control. On the 23rd December Vincent releases his tension by physically attacking Gauguin who returns hastily to Paris. Vincent mutilates his left ear.

**1889** His behaviour creates such commotion in the small town of Arles that he voluntarily departs from there for the mental home in Saint-Rémy—the old monastery of Saint-Paul-de-Mausole.

During this same period Theo marries Jo Borger (17th April, 1889). This hastens Van Gogh's decision to seek some shelter for himself, if need be in a hospital. The increasing power of the past, the intensified memories of his homeland and his youth, gain influence. His artistic views change at the expense of Impressionism and what he had acquired in Arles. He looks back to the early greyness. His line becomes even more turbulent than it already was in the last period in Arles. The symbolism of the sun declines in power. The moon and the stars become dominant parts of his intellectual orientation, as is apparent from the greater clarity of spiralling movement. He begins to revere Giotto (since his visit to Montpellier with Gauguin) and Puvis de Chavannes, alongside Monticelli and

Delacroix. He finds life in the monastery difficult but resigns himself to it.

The two worlds, that of the light and bright palette, of the sun in Provence and his Japanese dream, and the earlier world of greyness, Holland, and an imagined Italy, intensify his inner turmoil. In his work, bright and broken colours alternate; the chaotic whirling lines increase. Old principles (no contours, no Christ motifs) are temporarily replaced by new (contours, Christ figures after Delacroix). Already evident in Arles, the twin poles of this world come to full flowering in Saint-Rémy. Less realistic, the symbolic quality of his vision increases. Not old symbols but new sumbols taken from nature. Olive trees, blades of grass, moss on roofs, signify for him a complete world of thought and feeling.

**1890**  The young poet Albert Aurier, who understands the symbolic significance of Van Gogh's work, writes the first published study of it in the *Mercure de France*. Theo's family rejoices at the birth of a son named Vincent. Shortly afterwards, in February, Van Gogh's longing for the north begins to express itself in homesickness. It does not leave him. The south has lost its magical power over him. He fights against this reaction, for the south has given him much and he is grateful. But he wants to get away from the institution, and on the 16th May Theo meets his brother in Paris at the Gare de Lyon and introduces him to his young family for the first time. Vincent is to go to Auvers-sur-Oise, known to a number of painters. Its focal point is Dr Gachet who is an amateur etcher and painter, and has befriended the artists there.

Vincent leaves Paris on the 21st May to live in the Café Ravoux. He works feverishly in the surroundings of Auvers, where Gachet keeps an eye on him. In July he again goes to Paris, meets some painters and critics (Toulouse-Lautrec, Aurier) and sees work by Puvis de Chavannes in the Champ de Mars which increases his admiration for that painter. His work in Auvers is extremely erratic. His condition becomes even more unbalanced. His sense of space changes and becomes uncertain, his attitude to nature alters. He no longer finds in it either comfort or rest. As he wrote to his sister from Saint-Rémy: 'The feeling of loneliness overpowers me in the fields so dreadfully that I hesitate to leave the house.'

This feeling gains the upper hand and the healthy appearance and alertness he presents to visitors is deceptive. On the 29th July, Vincent dies in his room in the Café Ravoux after having shot himself in the chest on the 27th July, presumably behind a manure heap in a farmyard at Auvers. Gachet and his son took turns at attending him until Theo, warned by Gachet, took over the vigil up to the end.

The sale of a single picture—at the exhibition of the 'Vingt' in Brussels to the Belgian painter Anna Boch—and three articles on his work were the only signs of his future fame and the recognition of his significance that Van Gogh ever received in his lifetime.

# Extracts from the Letters of Van Gogh

These extracts are taken from *The Complete Letters of Vincent Van Gogh*, published in three volumes by New York Graphic Society Ltd., Greenwich, Connecticut, U.S.A., and by Thames and Hudson Ltd., London, 1958. Reprinted by courtesy of New York Graphic Society Ltd.

**To Theo** July 1880

Now I must bore you with certain abstract things, but I hope you will listen to them patiently. I am a man of passions, capable of and subject to doing more or less foolish things, which I happen to repent, more or less, afterwards. Now and then I speak and act too hastily, when it would have been better to wait patiently. I think other people sometimes make the same mistakes. Well, this being the case, what's to be done? Must I consider myself a dangerous man, incapable of anything? I don't think so. But the problem is to try every means to put those selfsame passions to good use. For instance, to name one of the passions, I have a more or less irresistible passion for books, and I continually want to instruct myself, to study if you like, just as much as I want to eat my bread. *You* certainly will be able to understand this. When I was in other surroundings, in the surroundings of pictures and works of art, you know how I had a violent passion for them, reaching the highest pitch of enthusiasm. And I am not sorry about it, for even now, *far from that land, I am often homesick for the land of pictures.*

133 Volume I

**To Theo** Cuesmes, 24 September 1880

I had said to myself, You must see Courrières. I had only 10 fr. in my pocket, and having started by taking the train, I was soon out of money; I was on the road for a week, I had a long, weary walk of it. Anyhow, I saw Courrières, and the outside of M. Jules Breton's studio. The outside of the studio was rather disappointing: it was quite newly built

of brick, with a Methodist regularity, an inhospitable, chilly and irritating aspect. If I could only have seen the interior, I would certainly not have given a thought to the exterior, I am sure of that. But what shall I say of the interior? I was not able to catch a glimpse, for I lacked the courage to enter and introduce myself.

I looked elsewhere in Courrières for traces of Jules Breton or some other artist; the only thing I was able to discover was his picture at a photographer's, and in a dark corner of the old church a copy of Titian's *Burial of Christ*, which in the shadow seemed to me to be very beautiful and of wonderful tone. Was it by him? I do not know, as I was unable to discern any signature.

136 Volume I

**To Theo**

It is the painting that makes me so happy these days. I restrained myself up to now, and stuck to drawing just because I know so many sad stories of people who threw themselves headlong into painting—who sought the solution of their problems in technique and awoke disillusioned, without having made any progress, but having become up to their ears in debt because of the expensive things they had spoiled.

I had feared and dreaded this from the start: I have considered drawing, and still do, the only way to avoid such a fate, and I have grown to love drawing instead of considering it a nuisance. Now, however, painting has unexpectedly given me much scope: it enables me to see effects that were unattainable before—just the ones which, after all, appeal to me most—and it enlightens me so much more on many questions and gives me new means by which to express effects. All together, these things make me very happy.

226 Volume I

**To Theo** Arles 1888-1889

In the end we shall have had enough of cynicism and scepti-

cism and humbug, and we shall want to live more musically. How will that come about, and what will we really find? It would be interesting to be able to prophesy, but it is even better to be able to feel that kind of foreshadowing, instead of seeing absolutely nothing in the future beyond the disasters that are all the same bound to strike the modern world and civilization like terrible lightning, through a revolution or a war, or the bankruptcy of worm-eaten states. If we study Japanese art, we see a man who is undoubtedly wise, philosophic and intelligent, who spends his time doing what? In studying the distance between the earth and the moon? No. In studying Bismarck's policy? No. He studies a single blade of grass.

But this blade of grass leads him to draw every plant and then the seasons, the wide aspects of the countryside, then animals, then the human figure. So he passes his life, and life is too short to do the whole.

Come now, isn't it almost a true religion which these simple Japanese teach us, who live in nature as though they themselves were flowers?

And you cannot study Japanese art, it seems to me, without becoming much gayer and happier, and we must return to nature in spite of our education and our work in a world of convention.

Isn't it sad that the Monticellis have never yet been reproduced in good lithographs or in etchings which vibrate with life? I should very much like to know what artists would say if an engraver like the man who engraved the Velasquez made a fine etching of them. Never mind, I think it is more our job to try to admire and know things for ourselves than to teach them to other people. But the two can go together.

**To Theo**          St. Rémy   May 1889 - May 1890
Have you noticed that the old cab horses there have large beautiful eyes, as heartbroken as Christians sometimes have? However it may be, we are neither savages nor peasants, and it is perhaps *even a duty* to like civilization (so called). After all it would probably be hypocrisy to say or think that Paris is bad when one is living there. Besides, the first time one sees Paris, it may be that everything in it seems unnatural, foul and sad.

**To J. J. Isaacson**
Well, probably the day is not far off when they will paint olive trees in all kinds of ways, just as they paint the Dutch willows and pollard willows, just as they have painted the Norman apple tree ever since Daubigny and César de Cock. The effect of daylight, of the sky, makes it possible to extract an infinity of subjects from the olive tree. Now, I on my part sought contrasting effects in the foliage, changing with the hues of the sky. At times the whole is a pure all-pervading blue, namely when the tree bears its pale flowers, and big blue flies, emerald rose beetles and cicadas in great numbers are hovering around it. Then, as the bronzed leaves are getting riper in tone, the sky is brilliant and radiant with green and orange, or, more often even, in autumn, when the leaves acquire something of the violet tinges of the ripe fig, the violet effect will manifest itself vividly through the contrasts, with the large sun taking on a white tint within a halo of clear and pale citron yellow. At times, after a shower, I have also seen the whole sky coloured pink and bright orange, which gave an exquisite value and colouring to the silvery grey-green. And in the midst of that there were women, likewise pink, gathering fruits.

These canvases, together with a number of flower studies, are all that I have done since our last correspondance. These flowers are an avalanche of roses against a green background, and a very big bouquet of irises, violet against a yellow background, against a pink background.

I begin to feel more and more that one may look upon Puvis de Chavannes as having the same importance as Delacroix, at least that he is on a par with the fellows whose style constitutes a hitherto, but no further, comforting for evermore.

<div align="right">614a Volume III</div>

**To Theo**

How kind you are to me, and how I wish I could do something good, so as to prove to you that I would like to be less ungrateful. The paints reached me at the right moment, because what I had brought back from Arles was almost exhausted. The thing is that this month I have been working in the olive groves, because their Christs in the Garden with nothing really observed, have got on my nerves. Of course with me there is no question of doing anything from the Bible—and I have written to Bernard and Gauguin too that I considered that our duty is thinking, not dreaming, so that when looking at their work I was astonished at their letting themselves go like that. For Bernard has sent me photos of his canvases. The trouble with them is that they are à sort of dream or nightmare—that they are erudite enough—you can see that it is someone who is gone on the primitives—but frankly the English Pre-Raphaelites did it much better, and then again Puvis and Delacroix, much more healthily than the Pre-Raphaelites.

It is not that it leaves me cold, but it gives me a painful feeling of collapse instead of progress. Well, to shake that off, morning and evening these bright cold days, but with a very fine, clear sun, I have been knocking about in the orchards, and the result is five size 30 canvases, which along with the three studies of olives that you have, at least constitute an attack on the problem. The olive is as variable as our willow or pollard willow in the North, you know the willows are very striking, in spite of their seeming monotonous, they are the trees characteristic of the country. Now

the olive and the cypress have exactly the significance here as the willow has at home. What I have done is a rather hard and coarse reality beside their abstractions, but it will have a rustic quality, and will smell of the earth. I should so like to see Gauguin's and Bernard's studies from nature, the latter talks to me of portraits—which doubtless would please me better.

<div align="right">615 Volume III</div>

**To Albert Aurier**

In the next batch that I send my brother, I shall include a study of cypresses for you, if you will do me the favour of accepting it in remembrance of your article. I am still working on it at the moment, as I want to put in a little figure. The cypress is so characteristic of the scenery of Provence; you will feel it and say: 'Even the colour is black'. Until now I have not been able to do them as I feel them; the emotions that grip me in front of nature can cause me to lose consciousness, and then follows a fortnight during which I cannot work. Nevertheless, before leaving here I feel sure I shall return to the charge and attack the cypresses. The study I have set aside for you represents a group of them in the corner of a wheat field during a summer mistral. So it is a note of a certain nameless black in the restless gusty blue of the wide sky, and the vermilion of the poppies contrasting with this dark note.

<div align="right">626a Volume III</div>

**To Emile Bernard**                                     Arles, April 1888

At the moment I am absorbed in the blooming fruit trees, pink peach trees, yellow-white pear trees. My brush stroke has no system at all. I hit the canvas with irregular touches of the brush, which I leave as they are. Patches of thickly laid-on colour, spots of canvas left uncovered, here and there portions that are left absolutely unfinished, repetitions, savageries; in short, I am inclined to think that the result is

so disquieting and irritating as to be a godsend to those people who have fixed preconceived ideas about technique. For that matter here is a sketch, the entrance to a Provençal orchard with its yellow fences, its enclosure of black cypresses (against the mistral), its characteristic vegetables of varying greens: yellow lettuces, onions, garlic, emerald leeks.

Working directly on the spot all the time, I try to grasp what is essential in the drawing—later I fill in the spaces which are bounded by contours—either expressed or not, but in any case *felt*—with tones which are also simplified, by which I mean that all that is going to be soil will share the same violet-like tone, that the whole sky will have a blue tint, that the green vegetation will be either green-blue or green-yellow, purposely exaggerating the yellows and blues in this case. B3(3) Volume III

**To his sister Willemien** Auvers-sur-Oise, June 1890
What impassions me most—much, much more than all the rest of my métier —is the portrait, the modern portrait. I seek it in colour, and surely I am not the only one to seek it in this direction. I *should like*—mind you, far be it from me to say that I shall be able to do it, although this is what I am aiming at—I *should like* to paint portraits which would appear after a century to the people living then as apparitions. By which I mean that I do not endeavor to achieve this by a photographic resemblance, but by means of our impassioned expressions—that is to say, using our knowledge of and our modern taste for colour as a means of arriving at the expression and the intensification of the character. So the portrait of Dr. Gachet shows you a face the colour of an overheated brick, and scorched by the sun, with reddish hair and a white cap, surrounded by a rustic scenery with a background of blue hills; his clothes are ultramarine—this brings out the face and makes it paler, notwithstanding the fact that it is brick-coloured. His hands, the

hands of an obstetrician, are paler than the face. Before him, lying on a red garden table, are yellow novels and a foxglove flower of a sombre purple hue. W22 Volume III

**To Emile Bernard**
Those Dutchmen had hardly any imagination or fantasy, but their good taste and their scientific knowledge of composition were enormous. They have not painted Jesus Christ, the Good God and so on—although Rembrandt *did* in fact —but he is the only one (and Biblical subjects are, relatively speaking, not numerous in his work). He is the only one, the exception, who has done Christs, etc. ... And in his case it is hardly like anything whatever done by the other religious painters; it is metaphysical magic.

Thus Rembrandt has painted angels. He paints a self-portrait, old, toothless, wrinkled, wearing a cotton cap, a picture from nature, in a mirror. He is dreaming, dreaming, and his brush resumes his self-portrait, but only the head, whose expression becomes more tragically sad, more tragically saddening. He is dreaming, still dreaming, and, I don't know why or how, but just as Socrates and Mohammed had their familiar spirits, Rembrandt paints behind this old man, who resembles himself, a supernatural angel with a da Vinci smile.

I am showing you a painter who dreams and paints from imagination, and I began by contending that the character of the Dutch painters is such that they do not invent anything, that they have neither imagination nor fantasy.

Am I illogical? No. B12 Volume III

**To Emile Bernard**
As for me, with my presentiment of a new world, I firmly believe in the possibility of an immense renaissance of art. Whoever believes in this new art will have the tropics for a home.

I have the impresssion that we ourselves serve as no more

than intermediaries. And that only the next generation will succeed in living in peace. Apart from all this, our duties and the possibilities of action for us can become clearer to us only by experience and nothing else. I am a bit surprised at the fact that I have not yet received the studies you promised me in exchange for mine.                     B19a Volume III

**To Emile Bernard**                  St Rémy, December 1889
However hateful painting may be, and however cumbersome in the times we are living in, if anyone who has chosen this handicraft pursues it zealously, he is a man of duty, sound and faithful. Society makes our existence wretchedly difficult at times, hence our impotence and the imperfection of our work. I believe that even Gauguin himself suffers greatly under it too, and cannot develop his powers, although it is in him to do it. I myself am suffering under an absolute lack of models. But on the other hand there are beautiful spots here. I have just done five size 30 canvases, olive trees. And the reason I am staying on here is that my health is improving a great deal. What I am doing is hard, dry, but that is because I am trying to gather new strength by doing some rough work, and I'm afraid abstractions would make me soft.                     B21 Volume III

# Notes on the illustrations

**Figure 1** Frontispiece *Self Portrait*. 1886-8. Paper, ink and pencil. 12½ × 9½ in. (31.5 × 24 cm.). Gemeentemusea, Amsterdam.

**Figure 2** *Head of a Woman*. Nuenen Period. 1883-85. Pen and ink wash. 8¼ × 5¼ in. (20.8 × 13.2 cm.). Rijksmuseum Kröller-Müller, Otterlo.
Van Gogh began drawing as a child. Later, when he wrote to his parents or his brother Theo, he illustrated his letters. It is not surprising that in the first few years he expressed his determination to paint mainly in landscapes and people. This head of a woman is similar to the drawings in ink which he made in The Hague period. He followed this same style in Drenthe and in his early Nuenen days until his vision was changed by reading Delacroix. This drawing is remarkable for its strong contrast of dark and light, the face pale and fragile against the dark mass surrounding it. This is characteristic of Van Gogh's work at this time.

**Figure 3** *Peasant with Walking Stick*. Nuenen Period 1883-85. Crayon. 13½ × 7½ in. (33 × 19 cm.). Rijksmuseum Kröller-Müller, Otterlo.
Van Gogh, whose ambition it was to be the painter of country life, observed the peasants at work, their characteristic expressions and attitudes, and recorded them with acute awareness and directness. He abandoned the academic approach and, as seen in this example, used a technique which presaged twentieth century expressionism. It was the whole figure, not the detail, which fascinated him and in this there is a certain resemblance to the work of the twentieth century Flemish painter, Constant Permeke. It was in Brabant that Van Gogh read Delacroix on drawing. The circle and the ellipse were the point of departure as this drawing demonstrates.

**Figure 4** *Peasant Woman with Shawl*. Nuenen Period. 1883-85. Black chalk. 13¾ × 8¼ in. (34.6 × 20.8 cm.). Rijksmuseum Kröller-Müller, Otterlo.
Mass fascinated him, contour came later. This was not a new conception, but the idea was revived in the nineteenth century by Delacroix, who was inspired by Rubens. Van Gogh in his turn, seeking truth and purity of expression, was influenced by Delacroix. With supreme mastery he succeeded in conjuring up the very essence of humanity from nothing more than a bundle of clothes.

**Figure 5** *Chair by the Stove*. Arles period. 1888-89. Pencil. 13 × 10 in. (32 × 25 cm.). Gemeentemusea, Amsterdam.
This drawing is from the period of La Maison Jaune at Arles when Van Gogh tried to realise his dream of a community of artists with Gaugin in 1888. Tragically the scheme failed. His work of this period seems to reflect his idealism in its stability and clarity, and approaches the classical.

**Figure 6** *Boats on the Sea at Saintes-Marie-de-la-Mer*. Arles period. 1888-89. Pen and ink. 9½ × 12 in. (24 × 31.5 cm.). Musées Royaux des Beaux Arts, Brussels.
The influence of Japanese art, particularly that of the woodcut, is apparent here. There is also great restlessness in the movement of the curves. This restlessness contrasts strongly, for example, with the classical calm of *Chair by the Stove* (figure 5).

He wrote to his sister that he had spent a week on the Mediterranean coast: 'What strikes me here, and what makes painting so attractive, is the clearness of the air...' (*The Complete Letters of Vincent Van Gogh*, page 437, Volume III).

'... I don't need Japanese pictures here, for I am always telling myself *that here I am in Japan*. Which means that I have only to open my eyes and paint what is right in front of me...' (page 443, Volume III).

**Figure 7** *Flower Bed*. Arles period. 1888-89. Pen and ink. 24 × 19½ in. (61 × 49 cm.). Gemeentemusea, Amsterdam. The almost chaotic theme of leaves and flowers shows how freely Van Gogh could now handle the forms of nature. The drawing is rhythmic, full of movement and tension. It is interesting to note that some of Raoul Dufy's work has similar characteristics.

**Figure 8** *Peasants Seated at Table*. St Rémy period. 1889-90. Charcoal. 9½ × 9¾ in. (24.5 × 25 cm.). Gemeentemusea, Amsterdam.

At this time Van Gogh was in the mental hospital in the old monastery of St Paul de Mausole at St Rémy. The peasants eating potatoes is a reference back to his famous *The Potato Eaters* of the Brabant period, symptomatic of his depression and the recurrence of the influence of his early life in the north. The curves and outlines of the figures are closely inter-related, giving the scene its dynamic character.

**Figure 9** *Cypress Trees*. St Rémy period. 1889-90. Black chalk. 12¼ × 9 in. (31 × 28 cm.). Rijksmuseum Kröller-Müller, Otterlo.

A particularly fine example of the Japanese influence already noted (figure 6). The drawing of the cypresses reveals the terrible nervous strain of his inner life. His hand follows the turbulent rhythm of his vision of the landscape wherein trees appear like dark flames and earth and the figures are fused in this consuming act of creativity.

## THE PLATES

**Plate 1** *Bois de la Haye with Girl in White*. The Hague, September 1882. 15½ × 23½ in. (39 × 59 cm.). Rijksmuseum Kröller-Müller, Otterlo.

'The other study of the wood', said Van Gogh in one of his letters, 'is of some large green beech trunks on the ground, covered with dry leaves, and the little figure of a girl in white. There was the great difficulty of keeping it clear and to bring atmosphere between the trunks that stand at different distances, and the place and relative bulk of those trunks change with the perspective—to make it so that one can breathe and walk around in it, and to make you smell the fragrance of the wood'.

Van Gogh collected English illustrated newspapers and magazines. He greatly admired the creators of these illustrations and made a study of them, as he was later to do with Japanese woodcuts. In this collection of magazines one can find much that consciously or subconscioulsy continued to affect him. Thus there is an English illustrator, McQuoid, who drew a similar motif. Van Gogh did not imitate it, but what he had seen by McQuoid unconsciously influenced him in the choice of his own motif from nature.

**Plate 2** *The Weaver*. Nuenen, May 1884. 27½ × 34 in. (70 × 85 cm.). Rijksmuseum Kröller-Müller, Otterlo.

In the late nineteenth century the weavers still formed a strange and isolated group of poor people. Van Gogh was deeply impressed by their difficult lives, and in Brabant he made many drawings and studies of them and took an interest in the technical side of their work. Beautifully built, well designed down to the smallest details, the loom stands in space completely one with the man. By virtue of its humanity, Van Gogh's vision is raised above Impressionism.

**Plate 3** *The Potato Eaters*. Nuenen, April 1885. 28½ × 37 in. (72 × 93 cm.). Rijksmuseum Kröller-Müller, Otterlo.

Van Gogh wanted to become the painter of the working peasant, and in this picture, of which he made a sketch, two versions and a lithograph, he gave a synthesis of his intentions. Previously he had produced many studies of peasant heads. 'I have tried to make it clear how those people, eating their

potatoes under the lamplight, have dug the earth with those very hands they put into the dish and it speaks of manual labour and how honestly they have earned their food. I wanted to give the impression of quite a different way of living than that of us civilised people. Therefore I am not at all anxious for everyone to like it or to admire it at once.' He painted this version 'on the spot, by lamplight', and the final version in his atelier, from memory.

This is the period in which he admired Millet and Zola for their earthiness, and in which he viewed with a religious reverence the signs of hard work in men who had become almost animal-like. At the same time this work is a symbol of his longing for family life with woman as the dominant element. The style of the painting is robust; expressiveness dominates anatomy. As a result of this he quarrelled with his painter friend Van Rappard, who defended academic correctness. The colour, under the influence of Delacroix, is in fact kept within a narrow compass that he himself termed a 'green soap colour'.

**Plate 4** *Head of a Peasant with Pipe*. Nuenen, November 1884. 17½ × 12½ in. (44 × 32 cm.). Rijksmuseum Kröller-Müller, Otterlo.
This head belongs to the period in which Van Gogh was obsessed by preparations for *The Potato Eaters* (plate 3). Here too there is a Delacroix-like colour. The form is angular and obstinate, like the peasant's nature, but like Van Gogh's own nature too. Self-identification seems to be becoming an ever more fundamental trait in his work.

**Plate 5** *Three Birds' Nests*. Nuenen, September—October 1885. 13×20 in. (33.5 × 50.5 cm.). Rijksmuseum Kröller-Müller, Otterlo.
He painted the background black to remove any impression that these were intended to be nests in the countryside. The

modelling is almost ghostly; the firm, round outline with a wreath of twigs and the dark hollowed-out centre remind one of the paintings of sunflowers with the large centres that he produced in Paris.

**Plate 6** *Still Life with Clogs*. Nuenen, 1884—85(?). 15½× 16⅜ in. (39 × 41.5 cm.). Rijksmuseum Kröller-Müller Otterlo.
This work is very thinly painted, which is unusual with Van Gogh. The mood is one of great intimacy. The objects are simple and belong to everyday life. This domestic side in Van Gogh was manifested during the Hague period and was in keeping with his respect for the French master of the still life and interiors, Chardin.

**Plate 7** *The Tower at Nuenen*. Nuenen, February 1884. 13½× 16½ in. (34.5 × 42 cm.). Rijksmuseum Kröller-Müller, Otterlo.
Van Gogh was attracted by this churchyard and the tower, which feature in fifteen drawings, two water-colours and ten paintings. He thinks here, as was the case later in France, more or less symbolically of the eternal renewal of things, of life and death. This is even further accentuated, at the beginning of the demolition of the tower (1885), in letters he wrote at that time.

The wideness of earth and sky is conveyed in broad strokes. The little crosses on the graves become distinct small accents, and next to them we see (clearly symbolic) a ploughing peasant. The essence of what later, in Saint-Rémy, gave rise to works such as *The Sower* (after Millet) and the small reaper in the large yellow cornfield, is already present here.

**Plate 8** *Smoked Herrings*. Paris, 1886. 17¾×15 in. (45×38 cm.). Rijksmuseum Kröller-Müller, Otterlo.
The first period in Paris continued the dark tones of the

Brabant palette but there were also short, nervous and lighter strokes and broad wild strokes which gave to the whole a richness lacking in Nuenen.

**Plate 9** *Le Moulin de la Galette* (new title: *The Mill 'Le Radet'*). Paris, 1886. 15¼ × 18½ in. (38.5 × 46 cm.). Rijksmuseum Kröller-Müller, Otterlo.
Though it is still known in critical literature as *Le Moulin de la Galette*, Parisians have discovered that this painting represents a windmill known as 'Le Radet' in the Rue Lepic. The palette is still Dutch, but the expressiveness of the townscape is more intense.

**Plate 10** *Red Gladioli and Other Flowers in a Vase*. Paris, 1886. 25¾ × 13¾ in. (65 × 35 cm.). Museum Boymans-Van Beuningen, Rotterdam.
Unable to afford models, Van Gogh did a series of colour studies in which the Dutch palette made way for more daring combinations. The format was at times narrow and tall (already Japanese influence?) and the brushwork showed the influence of Monticelli. His brushwork was freer in its modelling.

**Plate 11** *Still Life with Books (Romans Parisiens)*. Paris/Arles, 1888. 29 × 37 in. (73 × 93 cm.). Private Collection, Zürich.
Both in his early and in his late periods Van Gogh liked to include books in his paintings, but seldom without some hidden purpose. There is always something of his own history in the things he paints—the Bible, *la joie de vivre*—while writers' names are, so to speak, symbols which he includes in the colourful whole. There is a study of the same group, owned by V. W. Van Gogh, painted more schematically and vigorously. The painting reproduced here is executed entirely in the fine stipple of the late Parisian or early Arles periods (often difficult to distinguish). He views the objects

from above, as Signac and others had done. The displacement of surfaces of the untidily arranged books is broader and has more tension in the study, while in the copy reproduced here the colour is more sparkling and absolute. The other copy was painted to a greater extent under the influence of a particular lighting effect and is spatially more dynamic. The present picture might be called more Japanese, more detailed, almost more festive.

**Plate 12** *Le Moulin de la Galette*. Paris, c. 1886. 18 × 15 in. (45.3 × 37.8 cm.). Municipal Art Gallery and Museum Glasgow.
All the mills in Paris that Van Gogh painted are called 'Le Moulin de la Galette'. By comparing their positions it is clear that M. Baart de la Faille was right and that some of these must have been in the Rue Lepic, but this was not among them. In any case the arbitrariness and dereliction of the foreground attracted Van Gogh more than the windmill itself.

**Plate 13** *La Guinguette*. Paris, c. 1886. 19½ × 25½ in. (49 × × 64 cm.). Musée du Louvre, Paris.
This canvas of a simple café garden is from the changed but not yet wholly explained Parisian period. Van Gogh clearly regarded the vertical lines of the trees and a lantern in the middle as a major division within which the figures are drawn, everything being done broadly with that remarkable feeling for atmosphere which we can all recognise spontaneously without being able to define in words.

**Plate 14** *Self-portrait*. Paris, 1887. Oil on paper. 12½ × 9 (32 × 23 cm.). Rijksmuseum Kröller-Müller, Otterlo.
The self-portraits were for a large part produced in Paris. Often small in format, they give the impression of having been inspired by an urge for self-analysis as well as by prob-

lems he set himself in colour, as he had done with the flower pieces. At this time, 1887, his palette is that of the impressionists who, however, painted few self-portraits. It is remarkable how one senses a firm substructure beneath this fairly light style of painting.

**Plate 15** *Fritillaries in a Vase*. Paris, 1886. 29×23¾ in. (73×60 cm.). Musée du Louvre, Paris.

**Plate 16** *Flowers in a Blue Vase*. Paris, 1887. 24×15 in. (61×38 cm.). Rijksmuseum Kröller-Müller, Otterlo.
These two flower pieces (plates 15 and 16) belong to the period in which Van Gogh wanted to free himself from the grey Dutch harmonies in order to arrive at more violent colour. He did not shun brutal extremes, as he wrote to his English painter friend Levens in Antwerp, but neutralised them by broken tones. At this time he was already considering going south, to 'the land of blue tones and gay colours'. There is a hint of this blue dream in the summery bunch of flowers in the blue vase in plate 16. The flower piece from the Louvre (plate 15) reveals greater attention to form: the placing of the round vase on an angular surface with a nimbus around it and a background done in stipple technique gives dynamic power to the whole. The flower piece with the blue vase is milder in its mood, with refined tones in soft yellow and a feeling of light opulence which appears occasionally only in his Parisian period.

**Plate 17** *Le Père Tanguy*. Paris, 1887. 36½×28 in. (92×71 cm.). Musée Rodin, Paris.
Van Gogh made two portraits of the paint- and picture-dealer Tanguy. At the exhibition in the Jacquemart-André Museum in Paris (1960) it was possible to compare the two and realise that Van Gogh never repeated himself, for the viewpoint and the style of painting differ considerably. In

the sitting position and above all in the treatment of the hands folded in the sitter's lap, he anticipated the portraits he was to paint later in Arles. He set Tanguy against a wall on which Van Gogh celebrated his love of Japanese woodcuts. He made variations in both portraits, but the striking feature is the force of the presentation, achieved not only in the head, but through the composition. Any French painter with this varied and colourful palette would have been able to paint more fluently, not to say more pleasantly, whereas with Van Gogh the angularity remains perceptible through everything, the desire not to be pleasant but to let character predominate at all costs. In the midst of Impressionists and Neo-impressionists he distinguished himself, above all in the portraits, by a latent Expressionism.

**Plate 18** *Interior of a Restaurant*. Paris, 1887. 18×22½ in. (45.5×56.5 cm.). Rijksmuseum Kröller-Müller, Otterlo.

**Plate 19** *Restaurant de la Sirène, Joinville*. Paris, 1887. 21½× 26 in. (54×66 cm.). Musée du Louvre, Paris.
Unlike the café interiors he was to paint in Arles, Van Gogh in Paris subordinated the figure to the interior or townscape. But these rooms are very human and familiar. Again there is that delicate feeling of sensuous delight that appears in his pleasure at the light wood constructions out of which the Restaurant de la Sirène is assembled; insubstantial but adequate for its purpose. The atmosphere of the empty dining room, in which the expectation of coming guests brings the picture to life, is equally happy. He followed Signac and Seurat in the stipple technique, but the dividing of the colour was not carried out throughout any more than is the stippling. Van Gogh lacked Seurat's detachment in the stipple technique and was closer to Signac but entirely himself in his surrender to the essence of the objects. Not light and colour only but also the chairs, the bunches of flowers,

the upturned glasses and the top hat on the wall fascinated him.

**Plate 20** *Peach Trees in Blossom, 'Souvenir de Mauve'*. Arles, April 1888. 29×23½ in. (73×59.5 cm.). Rijksmuseum Kröller-Müller, Otterlo.

His arrival in Arles after the obsession of Paris gave Van Gogh new life. He enjoyed the melting snow and the blossoming of the peach trees shortly after. His Japanese dream grew more intense. He honoured the memory of his tutor, Mauve, in The Hague, whose death deeply affected him, with the picture of a blossoming tree as a present from Theo and Vincent to the family. For reasons unknown to us, Theo's name was not, however, included in the dedication. The canvas is, thanks to its subject, one of his most popular. But many will be impressed by its passionate lyricism, evoked by Provence and thoughts of Japan. The technique continues the drawing-like brushwork of the final Parisian period.

**Plate 21** *Gipsy Caravans (Les Roulottes)*. Arles, August 1888. 17½×20 in. (44×50 cm.). Musée du Louvre, Paris.

**Plate 22** *Plane Trees at Arles*. Arles, March 1888. 17¾×19¼ in. (44.7×48.5 cm.). Musée Rodin, Paris.

**Plate 23** *The Drawbridge at Arles, ('Pont de l'Anglois')*. Arles, March 1888. 21½×25¾ in. (54×65 cm.). Rijksmuseum Kröller-Müller, Otterlo.

**Plate 24** *View of Saintes-Maries*. Arles June 1888. 25¼×21 in. (64×53 cm.). Rijksmuseum Kröller-Müller, Otterlo.

**Plate 25** *Landscape near Arles*. Arles, 1889. 24½×30¼ in. (61.7×76.2 cm.). Courtauld Institute Galleries, London.

**Plate 26** *The Harvest near Arles*. Arles, 1888. 17½×19½ in. (44×49 cm.). Musée Rodin, Paris.

As Van Gogh usually travelled on foot his knowledge of the surroundings of Arles was very limited. (He could only reach Saintes-Maries, a little town on the coast with a fine fortified church, if he travelled in a coach through the marshy Camargue region, with its panoramas, its birds, and its peculiar light.) The flat countryside often reminded him of his native land and of the seventeenth century Dutch masters. Memories of Holland penetrated his Japanese vision.

In the first summer in Arles he produced the clearest landscapes he had ever painted, intense in their colour, powerful in their structure, and endowed with a searching vision which seems to penetrate to the essence of every thing and every living being. Such a landscape was the *View of Saintes-Maries* (plate 24), painted with confidence. The two landscapes near Arles (plates 25 and 26) are less tense but are seen in a similar mood, Dutch in its detail and southern in the powerful bright colours. Something of Anquetin, of Signac and of Seurat still continued to exert influence here, unsystematic, but firm in vision and in hand. The drawbridge was a motif that conjured up Dutch associations for him, but the intensity of the colour is un-Dutch. He here achieved the miraculous Provencal blue of which he had already dreamt in Paris without ever having seen it. Compared to Cézanne's blue, Van Gogh's derives from a totally different sensibility. Cézanne always connects the blue with what he wants to achieve by way of spatial sensation based on colour. There is in Cézanne's blue an urge towards objectivity, towards something beyond the personal, whereas with Van Gogh the blue is a subjective experience which, in the first summer months in Arles, rose to a subjective ecstasy. The intensity of this blue was the result of the psychological concentration which must have obsessed Van Gogh to a high degree in the months before Gauguin's arrival.

**Plate 27** *Café Terrace at Night (Place du Forum, Arles)*. Arles, 1888. 32×26 in. (81×65.5 cm.). Rijksmuseum Kröller-Müller, Otterlo.

**Plate 28** *The Schoolboy (Le collégien)*. Saint-Rémy, January 1890. 25×21½ in. (63×54 cm.). Museu de Arte, São Paulo.

**Plate 29** *The Postman Roulin*. Arles, February—March 1889. 25¾×21½ in. (65×54 cm.). Rijksmuseum Kröller-Müller, Otterlo.

**Plate 30** *Armand Roulin*. Arles, November 1888. 25¾×21½ in. (65×54 cm.). Museum Boymans-Van Beuningen, Rotterdam.

**Plate 31** *Girl from Arles (La petite Arlésienne)*. Arles, 1888. 20¼×19½ in. (51×49 cm.). Rijksmuseum Kröller-Müller, Otterlo.

In the late summer before Gauguin's arrival (20th October) Van Gogh had already betrayed signs of an increasing instability. His sun-worship and inner concentration decreased. Everything shifted towards a darker phase with the night (moon and stars) exercising a great attractive power over him. Anquetin's *Avenue de Clichy at Evening* may have been present in his memory as he painted the *Café Terrace at Night* (plate 27), but Van Gogh's own nature took the upper hand in the fierceness of its colour and in the brushwork. The canvas has no unity, but the scintillating light and darkness is so intensified that the colour almost disrupts the form and composition. In any case the period of the clear firmness of the drawbridge and of Saintes-Maries was past.

The portraits produced in Arles have a style of their own, and it is to these that *The Schoolboy* (plate 28) belongs. As soon as Gauguin arrived, there came into Van Gogh's work an element of stylisation, of (partially) flat colour and a use of strong contour (previously opposed by Van Gogh). For a time he gave in to the 'cloisonné' theory of Gauguin and Bernard. The family of the postman Roulin, with whom mutually cordial relations existed, supplied him with excellent models. He saw alternately the individual and the type, critically yet warmly, with a tendency to glorification. *La Petite Arlésienne* (plate 31) is a little miracle of tenderness and refinement in colour. The jade green in the face, the background of a rarefied, pale rose and the deep blue-black of her hair reveal mature mastery over the palette.

**Plate 32** *Sunflowers*. Arles, August 1888. 36⅜×28⅞ in. (92.5×73 cm.). National Gallery, London.

**Plate 33** *Girl Reading*. Arles, November 1888. 28¾×36¼ in. (72.4×91.3 cm.). Private Collection, Paris.

**Plate 34** *Portrait of Milliet (Sous-lieutenant des Zouaves)*. Arles, September 1888. 23¾×19¾ in. (60×50 cm.). Rijksmuseum Kröller-Müller, Otterlo.

One of the tasks Van Gogh set himself, under pressure from Gauguin, and against his will, was working from memory. He had only moderate success. The figures became schematic, everything became flatter (as in Plate 33), but the colour remained completely Van Gogh.

He wanted to use the *Sunflowers* (plate 32), begun in Paris, as decoration by the time Gauguin came to La Maison Jaune, where they were to live together. It is one of Van Gogh's most central motifs. In form it is a transformation of the *Three Birds' Nests* (plate 5) painted at Nuenen; in colour a climax of yellows in all shades, a colour in which for him love and the sun are united. He also speaks of 'a symphony in blue and yellow'.

**Plate 35** *The Chair and the Pipe*. Arles, 1888—89. 36⅛×28¾ in. (92×73 cm.). Tate Gallery, London.

**Plate 36** *Self-portrait with Mutilated Ear*. Arles, January 1889. 23⅜×18¾ in. (59×47 cm.). Courtauld Institute Galleries, London.

These two works (plates 35 and 36) are witness to the drama that was enacted in Arles between Gauguin and Van Gogh. *The Chair and the Pipe* by Vincent has as its pendant Gauguin's *Empty Chair* with two books and a burning candle. Van Gogh's chair was yellow, Gauguin's red and green. He was already familiar with the motif of the empty chair from English illustrations which he had previously collected and which he admired, as a Romantic, not least for their narrative element. Now he was overwhelmed by Gauguin's departure and portrayed his emotions in the symbolism of chairs, objects impregnated with human feelings.

He confronted himself in the mirror with the wound he had given himself in his excitement after the quarrel with Gauguin. The undaunted way in which he sees himself and the assurance of his hand give these portraits a disturbing calm. The two versions differ in quality, as is the case with all his repetitions. The portrait with the pipe (Chicago Leigh Block Collection) is the most concentrated and simple. The Courtauld portrait, with its background of a Japanese print, gives the atmosphere of an interior, which does not work as rigorously and austerely in the composition as does the portrait with the pipe. The Courtauld portrait is duller in its mood. The positive elements in the facial expression give way to alarm; the figure seems almost to retreat while in the portrait with the pipe, the passion and the tension of the action are alive. The Courtauld portrait is more contemplative. It is not an attempt to copy the first portrait but another interpretation of his fluctuating mental condition.

**Plate 37** *The Garden of Saint-Paul's Hospital at Saint-Rémy*. Saint-Rémy, May—June 1889. 37½×29¾ in. (95×75.5 cm.). Rijksmuseum Kröller-Müller, Otterlo.

**Plate 38** *Cypresses with Two Figures*. Saint-Rémy, June 1889 —February 1890. 36½×29 in. (92×73 cm.). Rijksmuseum Kröller-Müller, Otterlo.

**Plate 39** *The Road with Cypresses and Star*. Saint-Rémy, May 1890. 36½×29 in. (92×73 cm.). Rijksmuseum Kröller-Müller, Otterlo.

**Plate 40** *Evening Walk*. Saint-Rémy, October 1889. 19½× 17¾ in. (49×45 cm.). Museu de Arte, São Paulo.

The motifs of Saint-Rémy are in the main restricted to the garden and the buildings of the old monastery of Saint-Paul, its immediate surroundings (les Alpilles), people from the institution, and interpretations of paintings by Delacroix and Millet and engravings by Daumier, Lavieille and Doré. *Cypresses with Two Figures* (plate 38) was intended as a present for Albert Aurier, who in 1890 published in the *Mercure de France*, the first important study of Van Gogh's significance. The landscape with cottages and figures becomes in this period one organic whole, characterised by whirling strokes, many spiral movements, and an expressiveness that transforms everything.

*The Road with Cypresses and Star* (plate 39) and *Evening Walk* (plate 40) are examples of extremely turbulent landscapes in which figures, which have something desperate about them, walk as if driven by fate. The lucidity of Arles has entirely vanished.

**Plate 41** *Les Alpilles* (near Saint-Rémy). Saint-Rémy, March —April 1890. 23¼×28½ in. (59×72 cm.). Rijksmuseum Kröller-Müller, Otterlo.

**Plate 42** *Prisoners' Round* (after Gustave Doré). Saint-Rémy, February 1890. 31½×25¼ in. (80×64 cm.). Puschkin Museum, Moscow.

**Plate 43** *Old Man in Sorrow* (after his own lithograph of the Hague period). Saint-Rémy, May 1890. 32 × 25 ½ in. (81 × 65 cm.). Rijksmuseum Kröller-Müller, Otterlo.

**Plate 44** *Cornfield and Cypresses*. Saint-Rémy, 1889. 28 ½ × 36 in. (72.5 × 91 cm.). National Gallery, London.
Van Gogh's style in the last Saint-Rémy period (January—May 1890), before he went to Auvers, was changed by his attempts to win back something of his Dutch period from Impressionism. He looks again for broken tones, though it is only the violent and fierce colours that return. Compare for instance plate 43, *Old Man in Sorrow*, an example of the supremacy of memories in a pale style of painting, with plate 41, *Les Alpilles*, which is painted brightly, powerfully and positively. He copied *Prisoners' Round* (plate 42) from Gustave Doré; that is to say he realised a transcription of it in oils, but it is merely legend that he included himself among the prisoners. Comparison with Doré's print reveals a remarkable, almost nervous correctness. A somewhat sombre, greenish element, reminiscent of the period of *The Potato Eaters* (Nuenen), comes into the colour.

**Plate 45** *Chestnut Tree in Blossom*. Auvers, May 1890. 25 × 20 in. (63 × 50.5 cm.). Rijksmuseum Kr öller-Müller, Otterlo

**Plate 46** *View at Auvers*. Auvers, July 1890. 19 ¾ × 39 ½ in. (50 × 100 cm.). National Gallery, London. –

**Plate 47** *Three Trees and a House*. Auvers, June 1890. 25 ¼ × 31 in. (64 × 78 cm.). Rijksmuseum Kröller-Müller, Otterlo.

**Plate 48** *Church at Auvers*. Auvers, June 1890. 37 ¼ × 29 ¼ in. (94 × 74 cm.). Musée du Louvre, Paris.
From the four paintings from Auvers reproduced here (plates 45—48) we can see that Van Gogh's feverish production became very uneven. It had its climaxes but also its moments of uncontrol. His internal struggle was at its most violent. He had not left the south without a struggle and the north brought him no peace. His line became looser, sometimes an 'Art Nouveau' line. His colour was in turn greyish and mixed or highly intensified, as in the *Church at Auvers*. He thought, as he painted, of the little, old church in his birthplace, Zundert, where his father was buried. The wavy line, as in *View at Auvers*, gives a dynamism to the landscape, almost Baroque, in which everything (figures, trees, houses, roads) appears deformed. But there are exceptions, such as the perfect landscape in the Pushkin Museum in Moscow of the road near Auvers. Placed next to this, the landscape with the three trees and the heavy white cloud (plate 47) is like a flame leaping out.

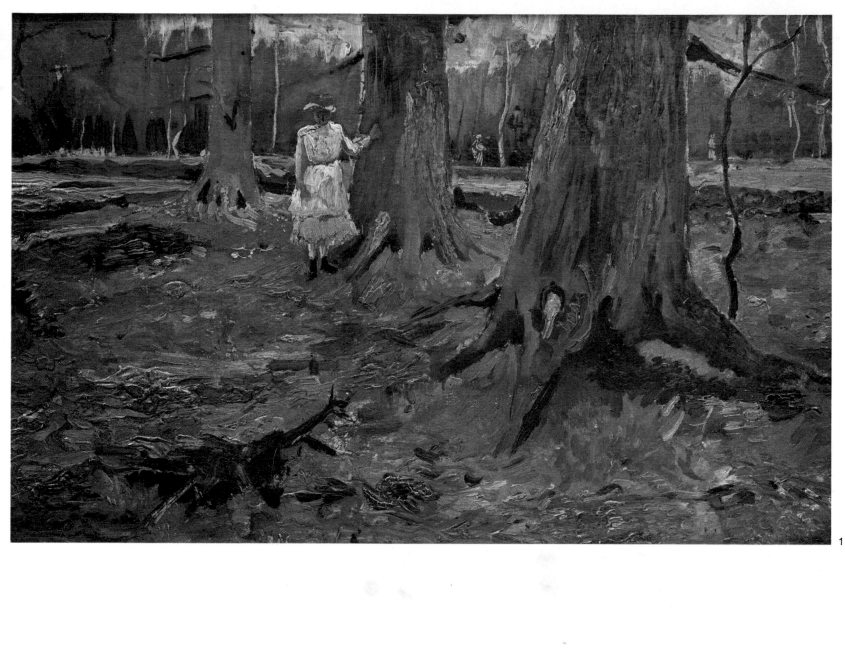

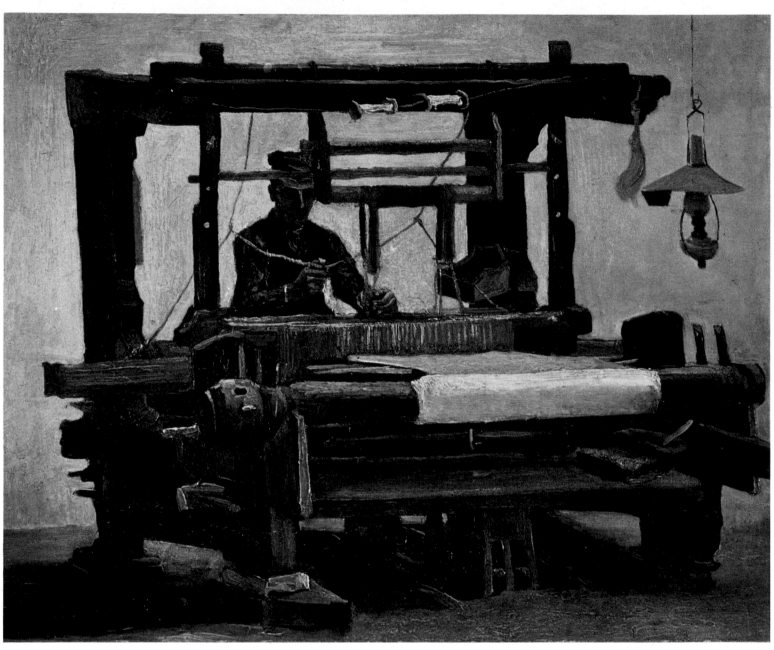

2

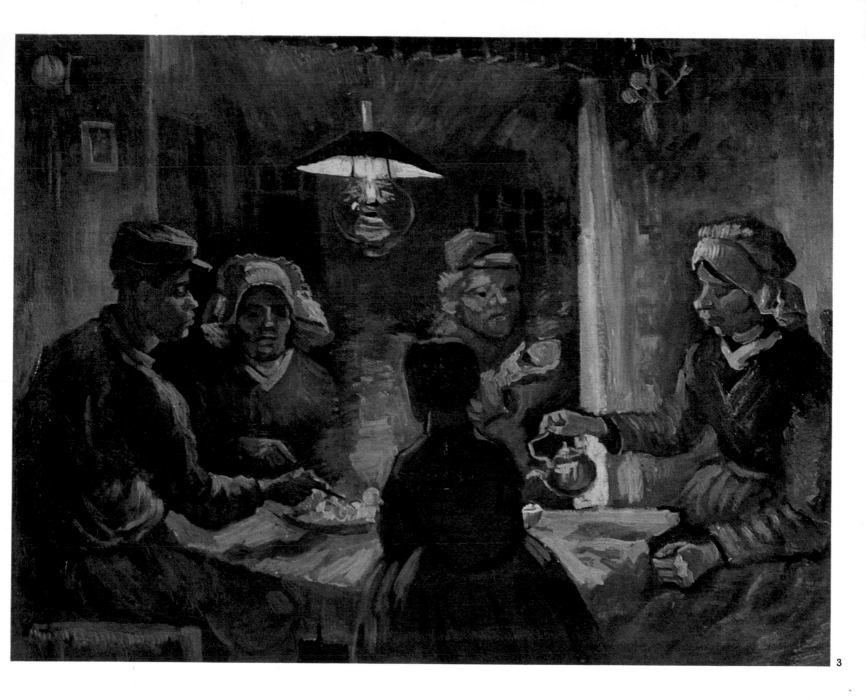

3

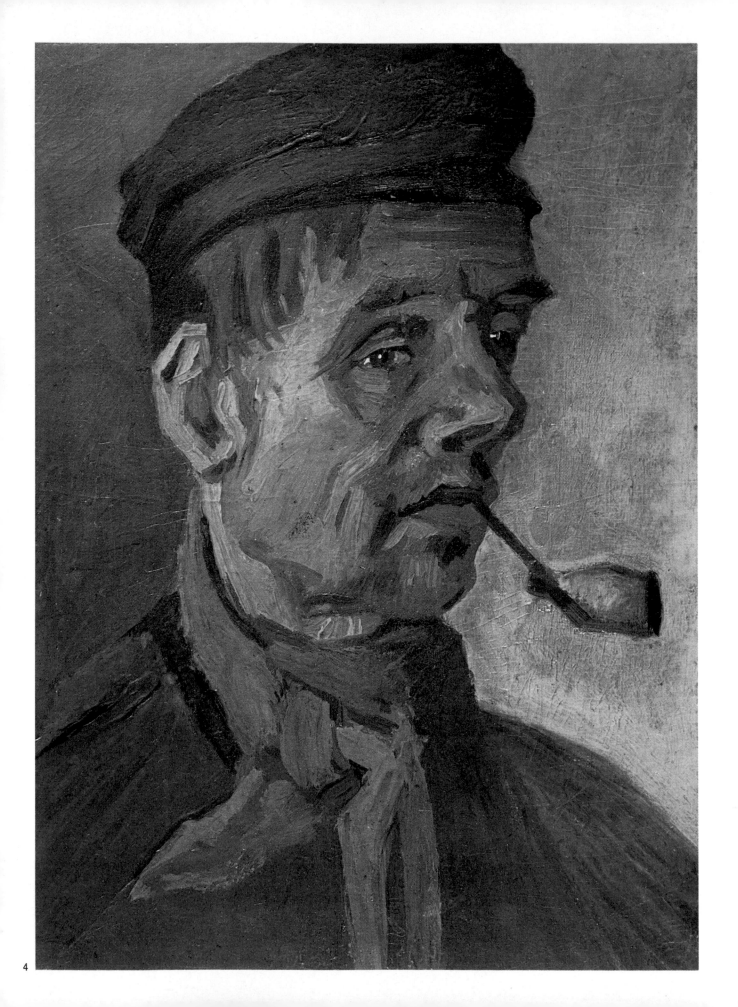

4

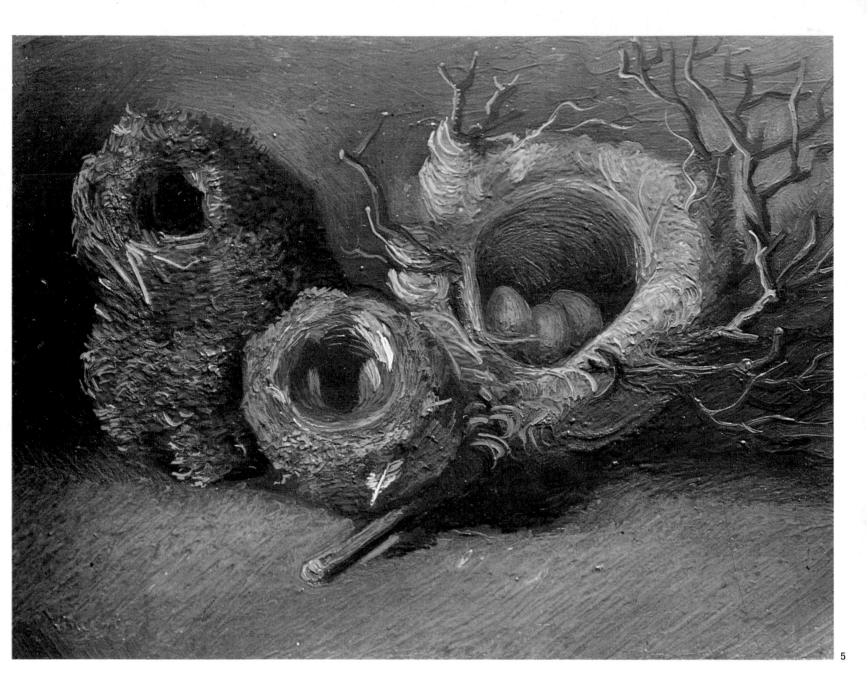

5

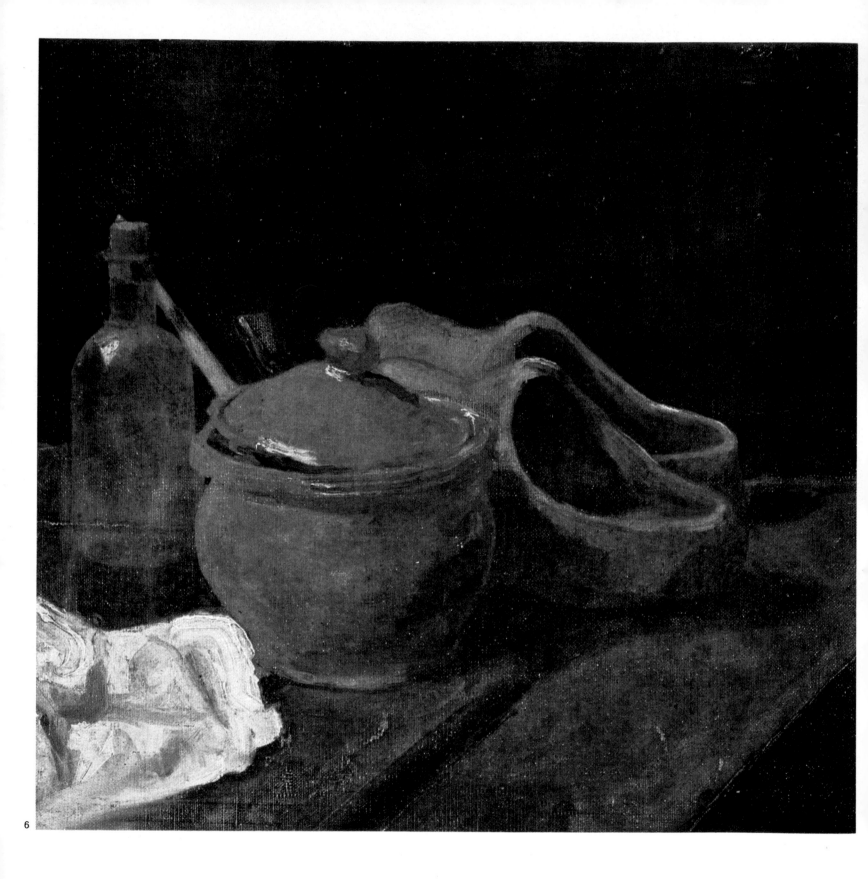

6

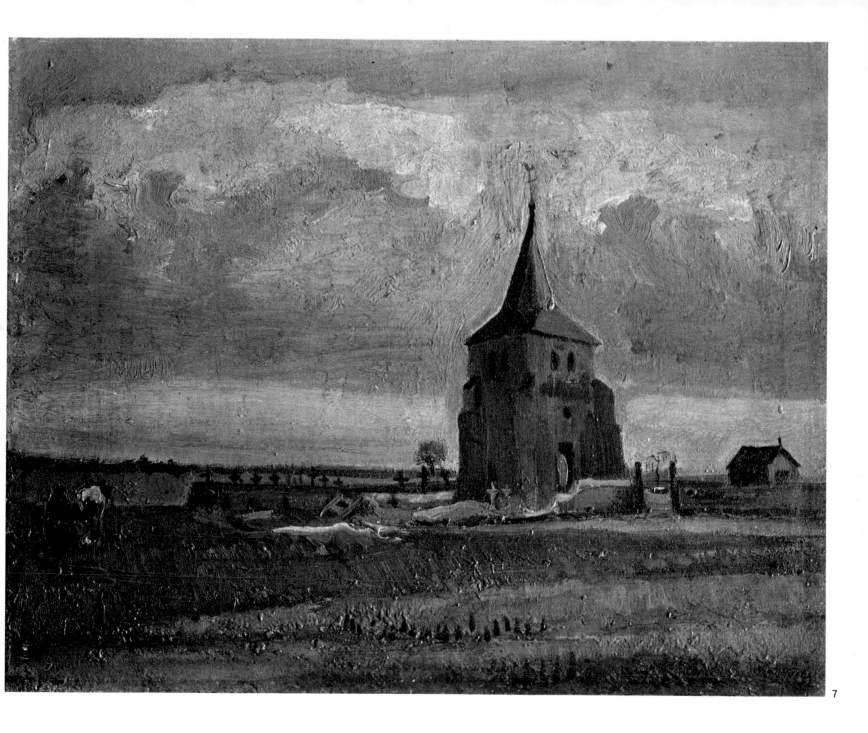

7

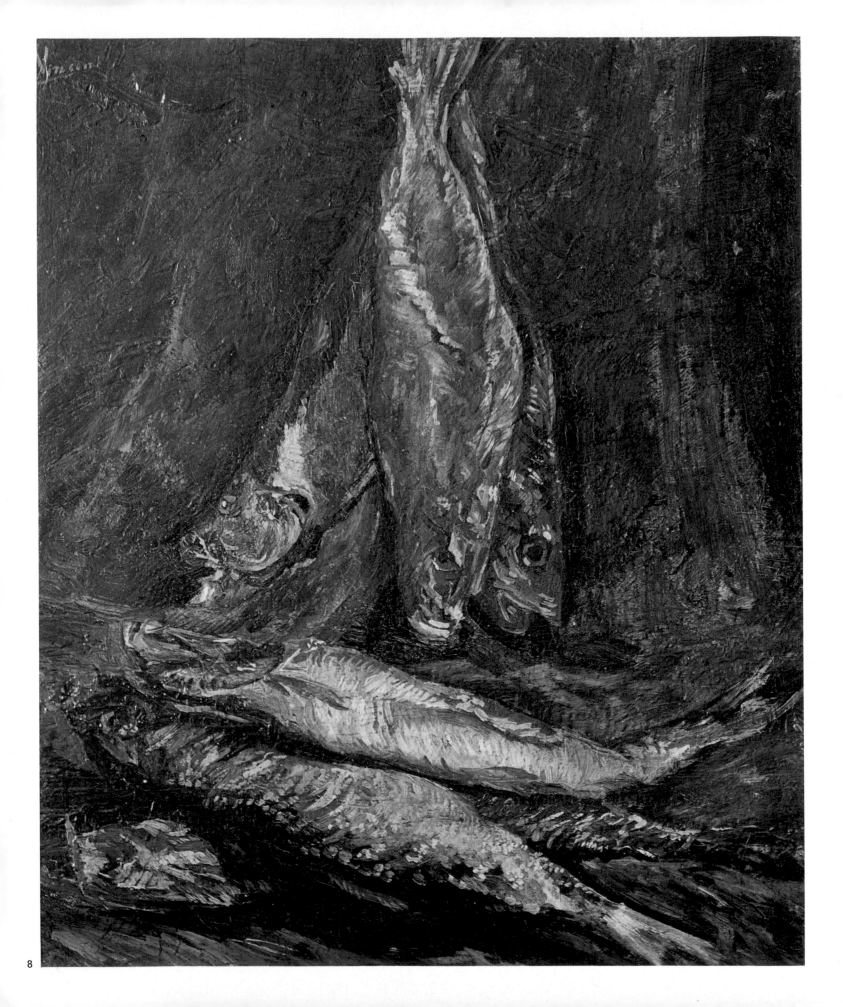

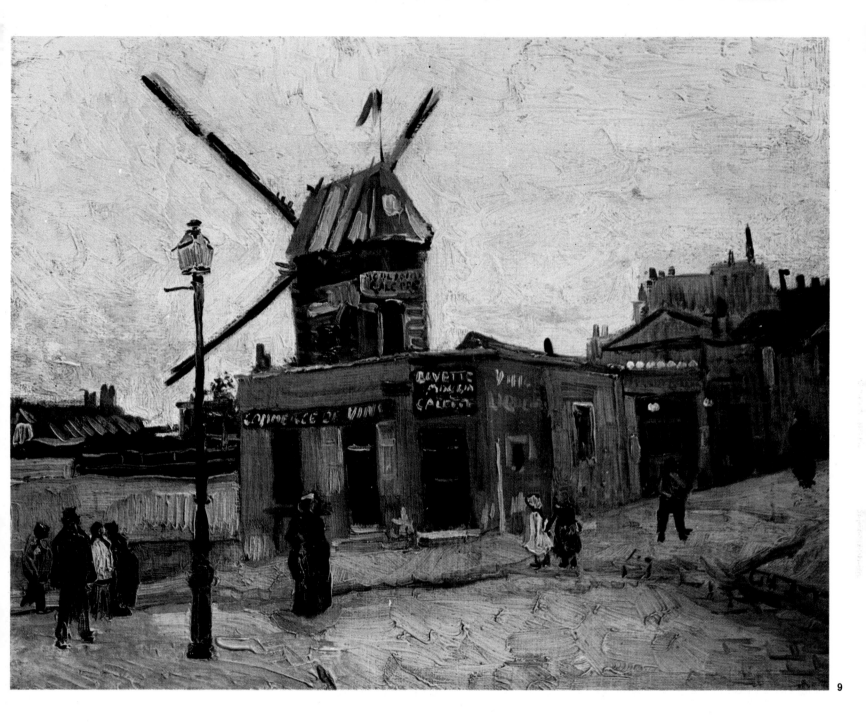

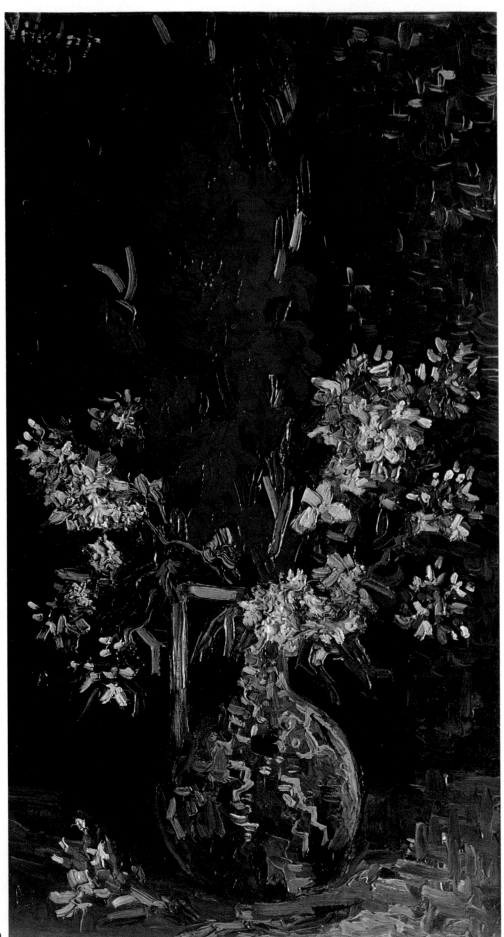

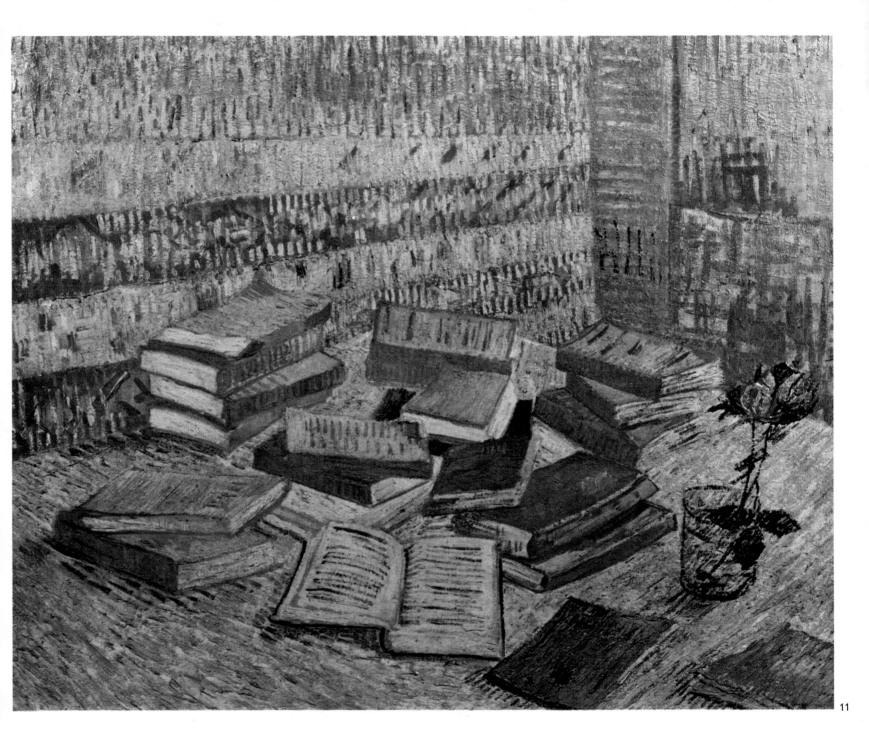

11

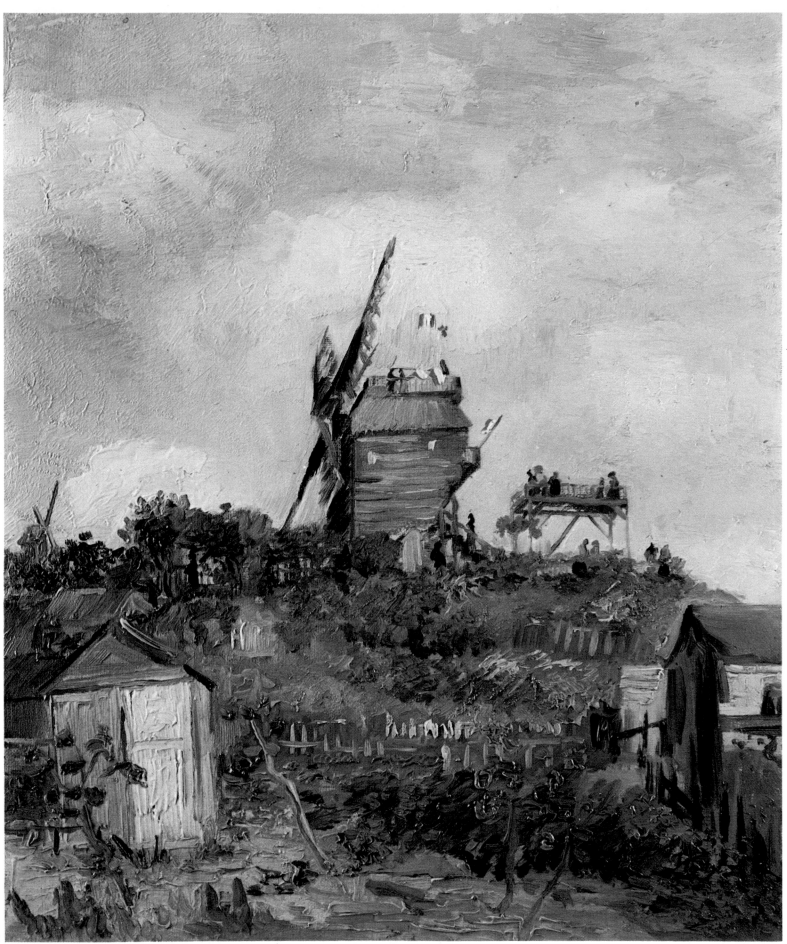

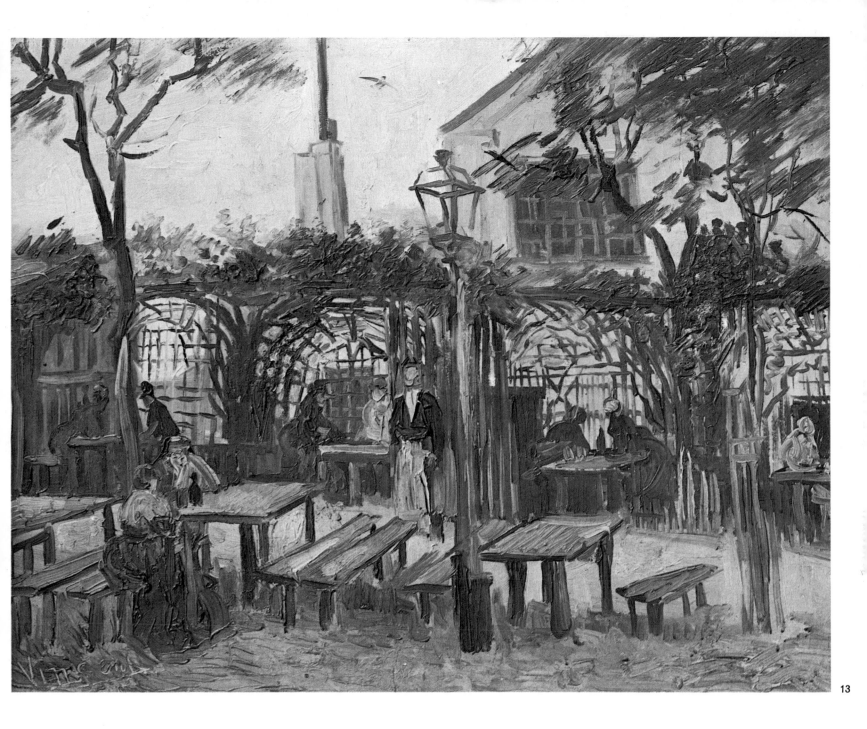

13

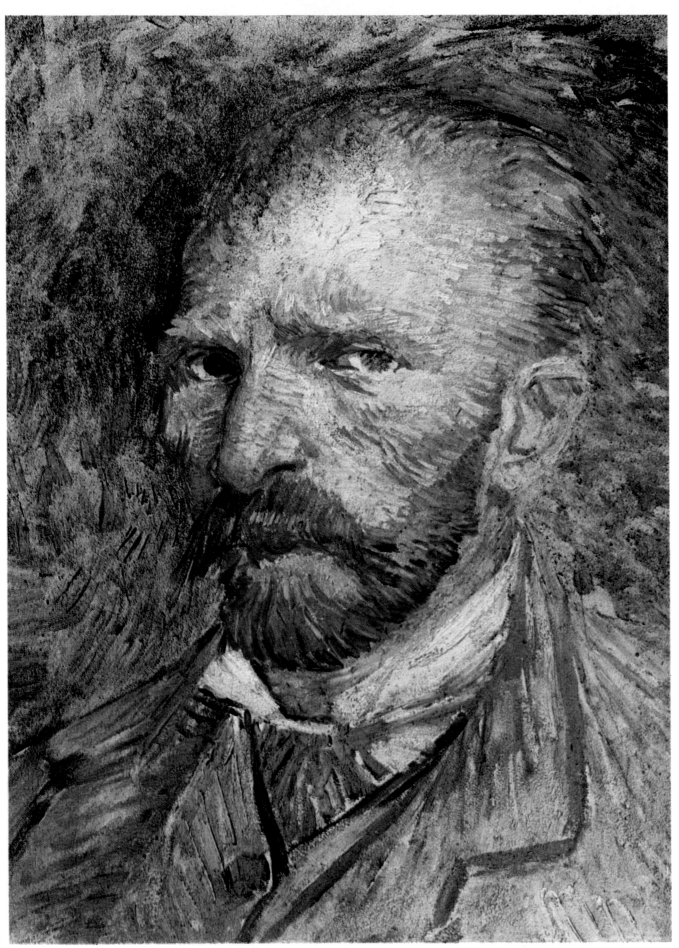

14

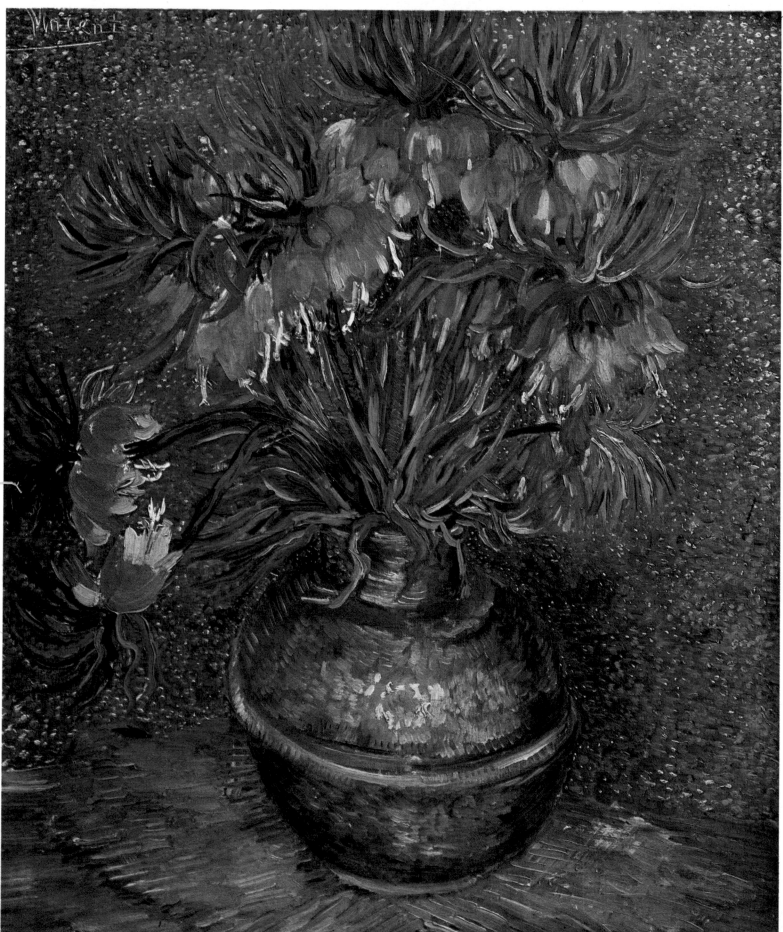

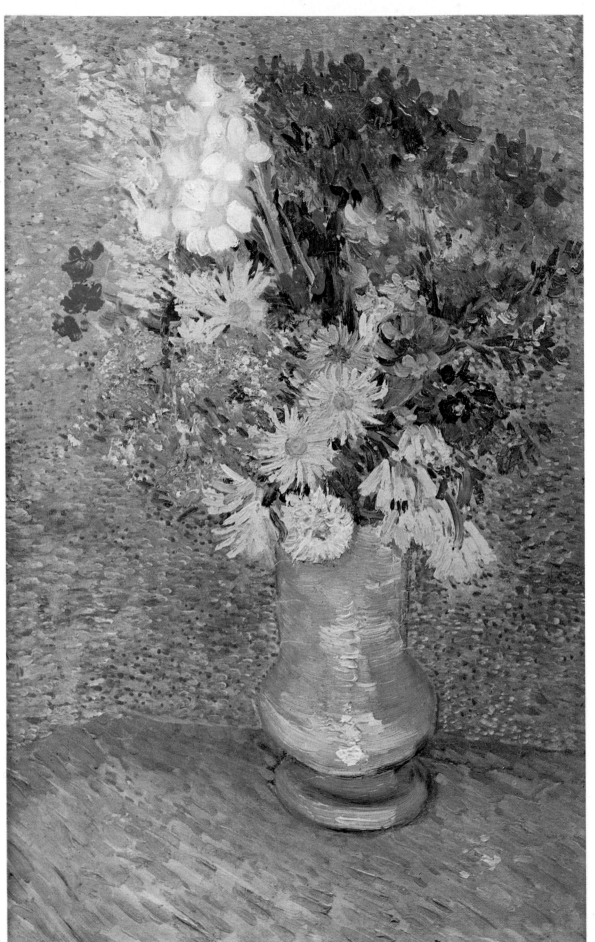

16

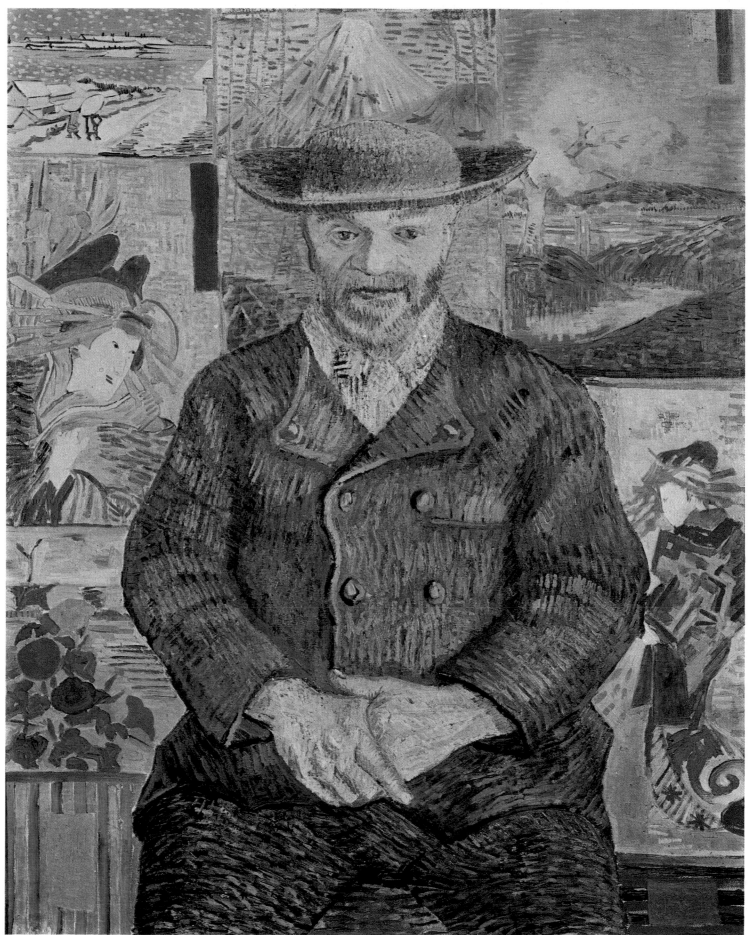

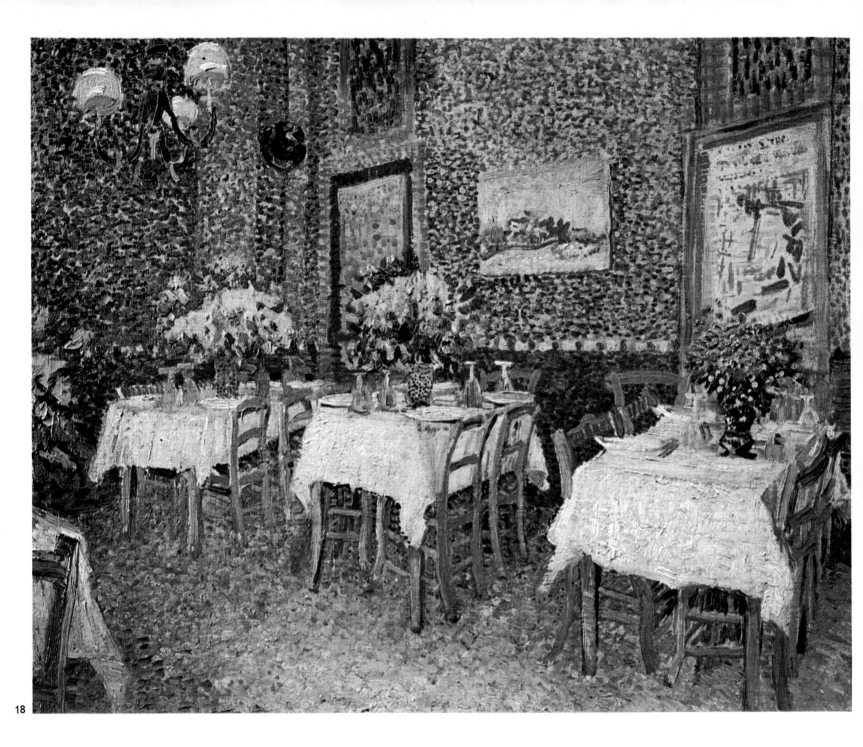

18

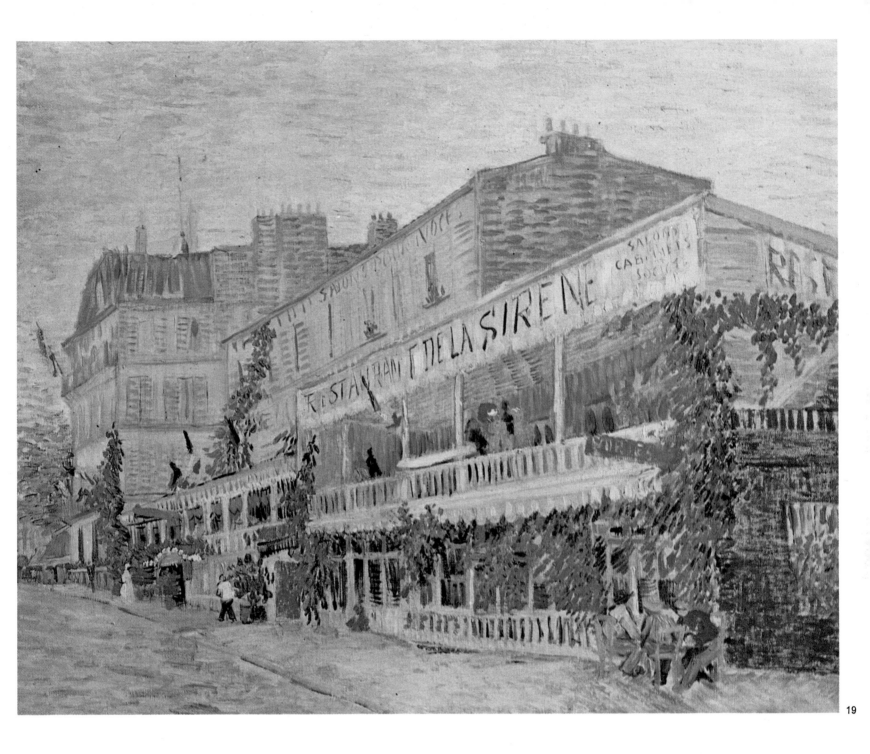

19

Souvenir de Mauve
Vincent

20

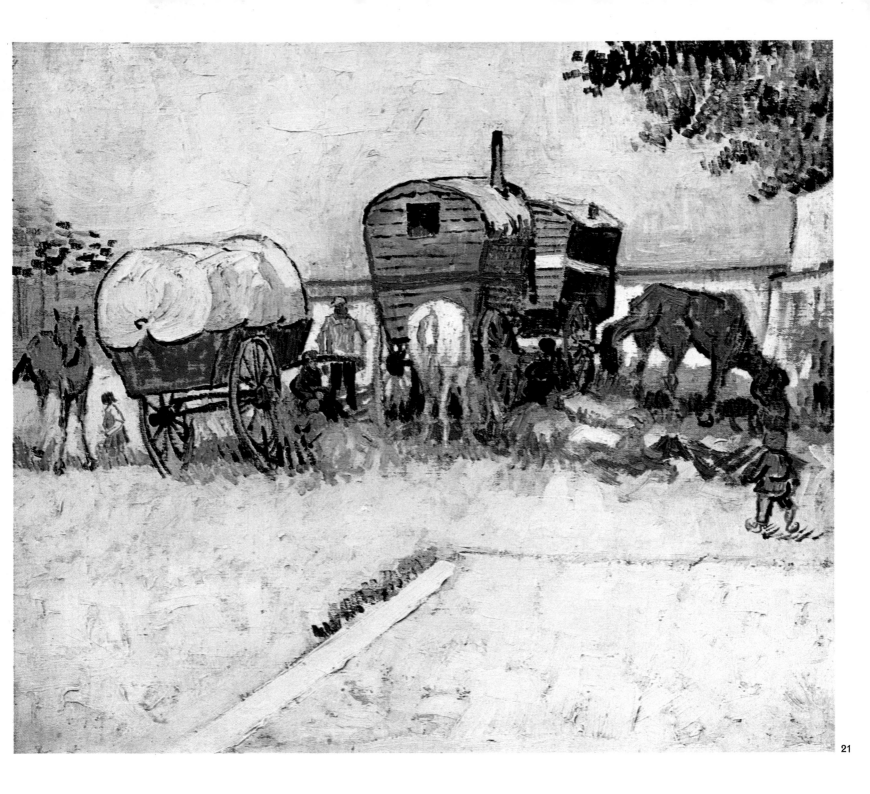

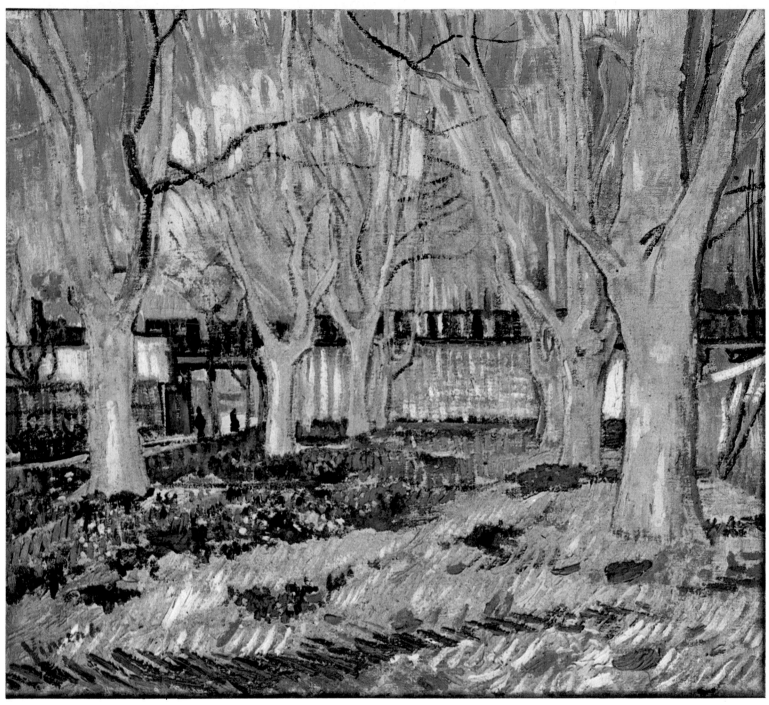

22

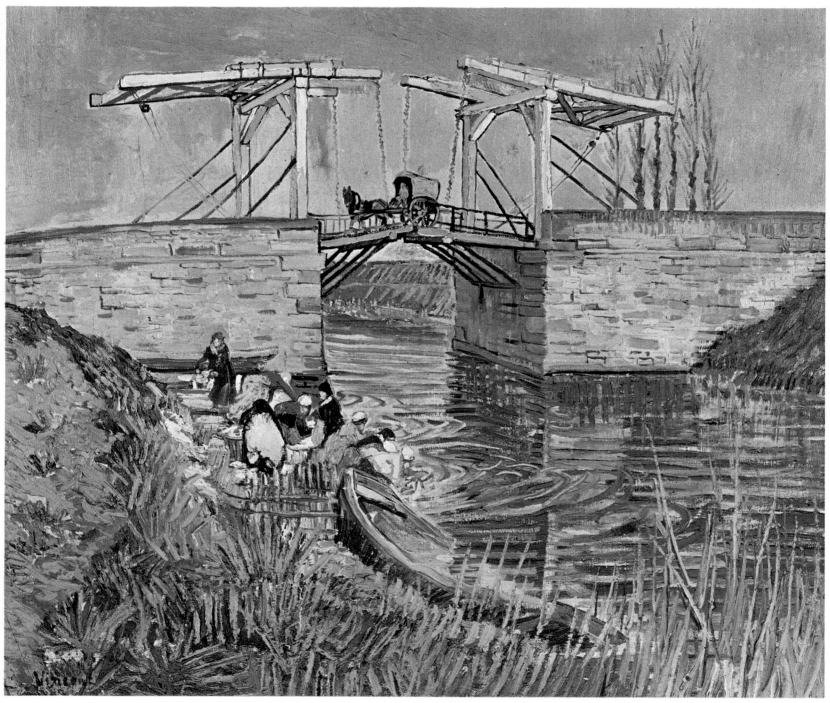

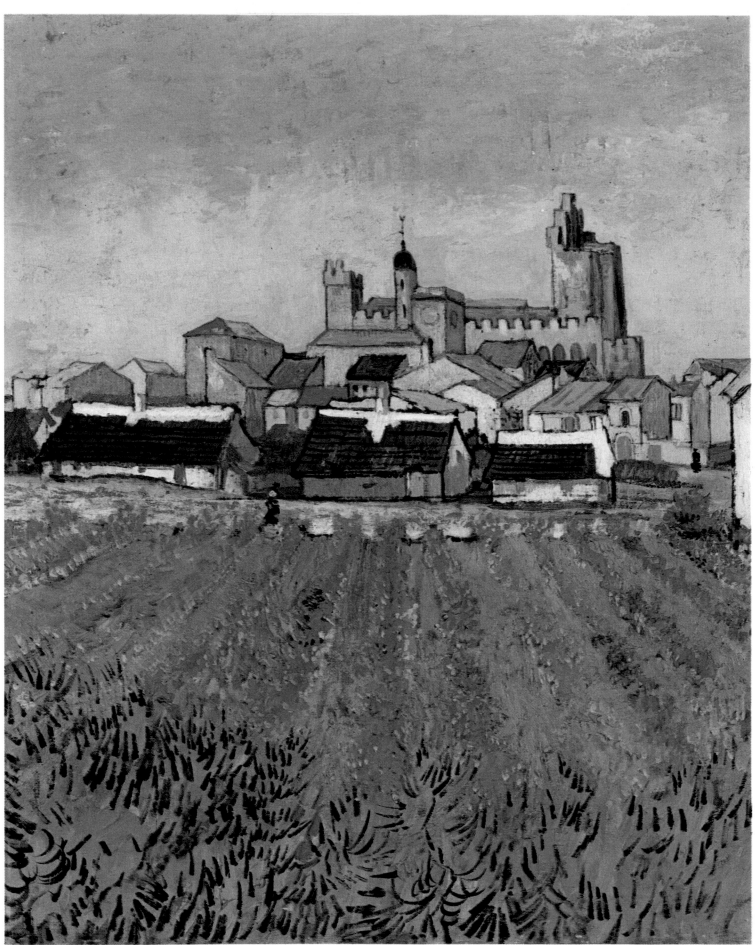

24

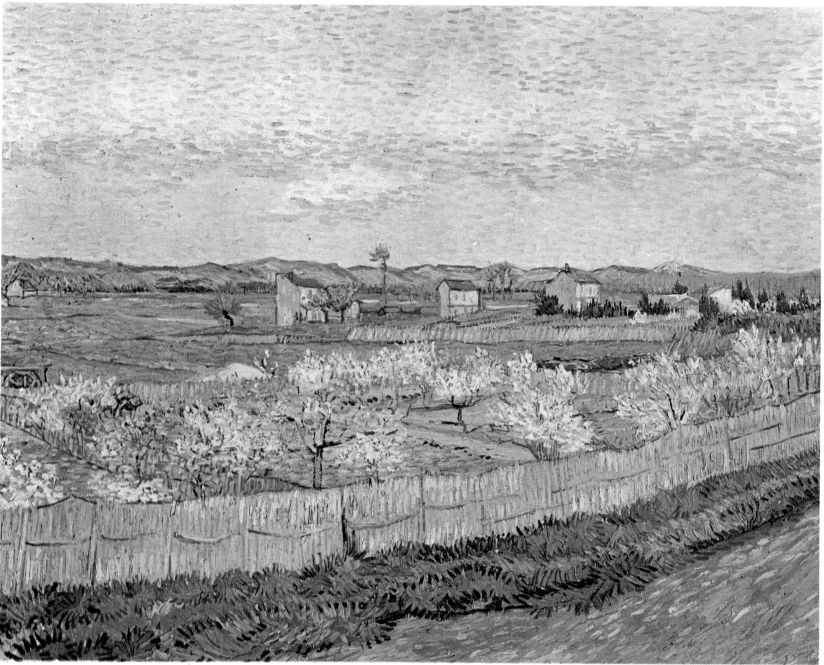

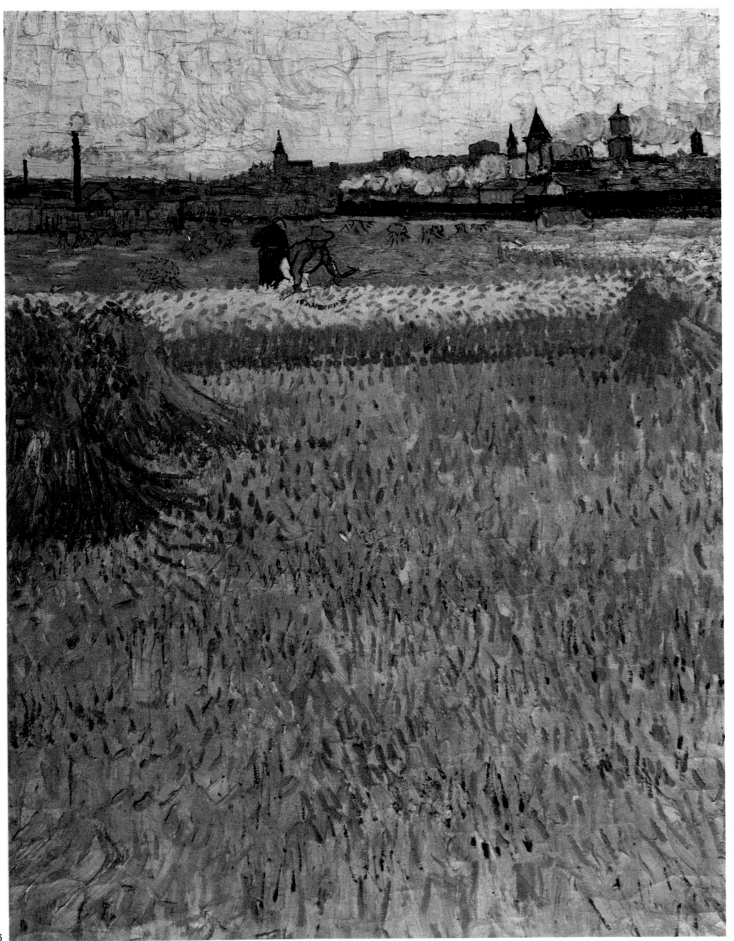

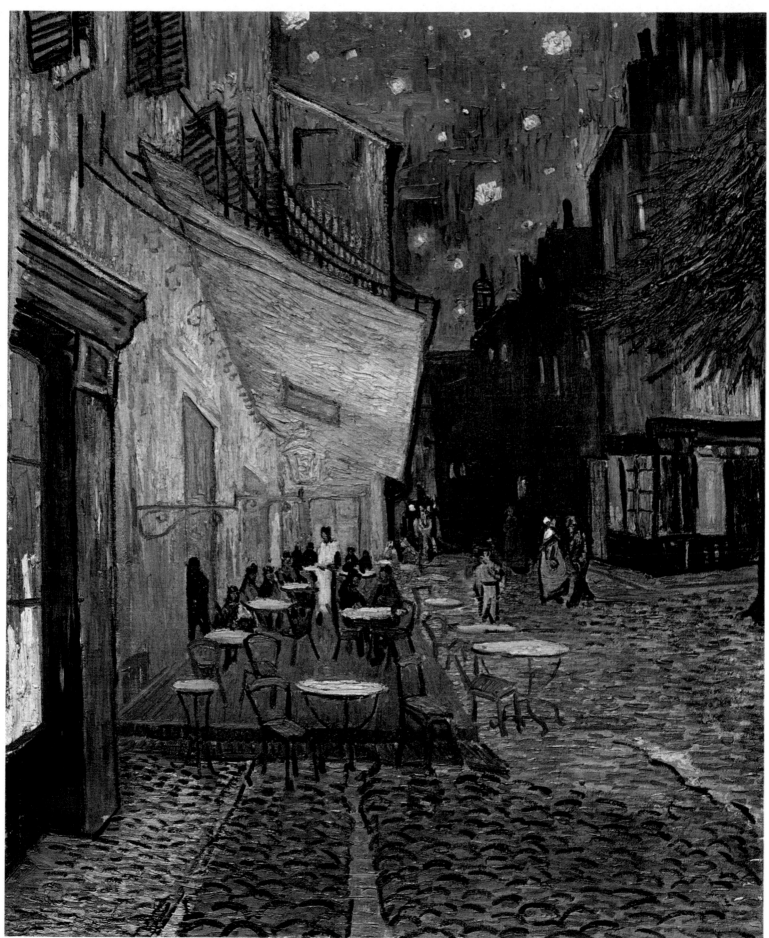

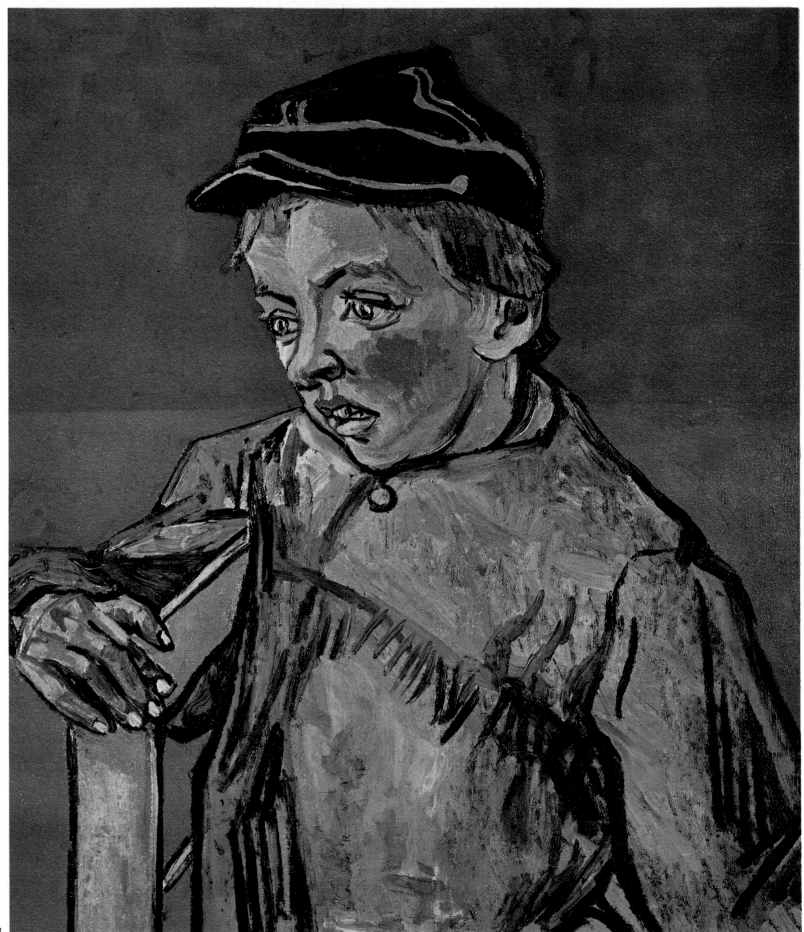

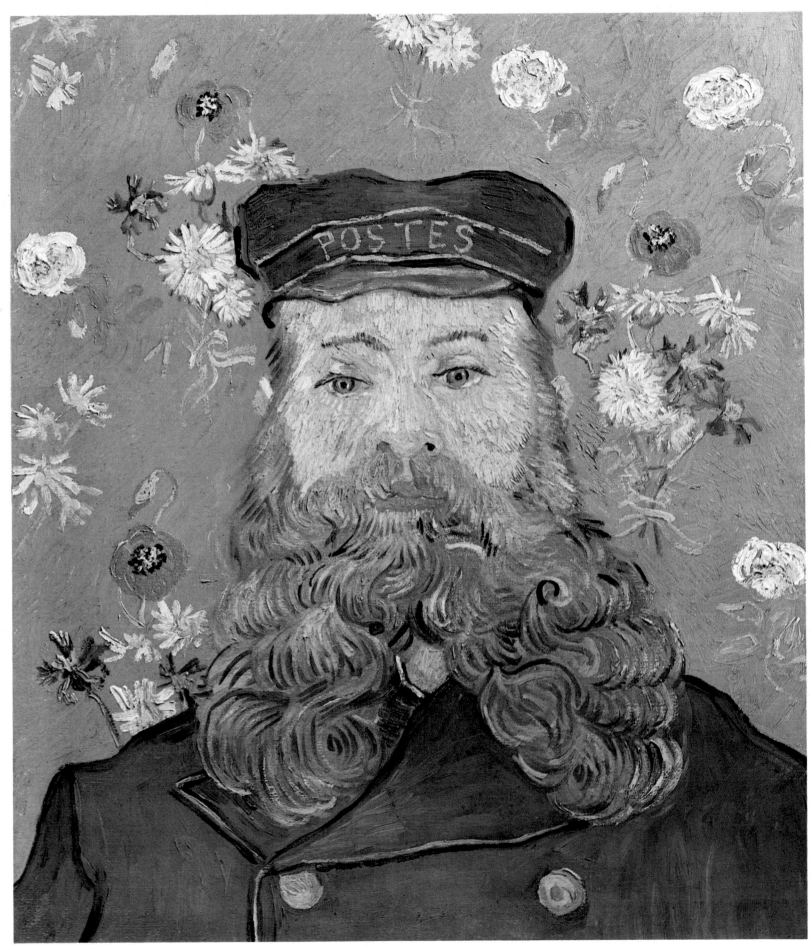

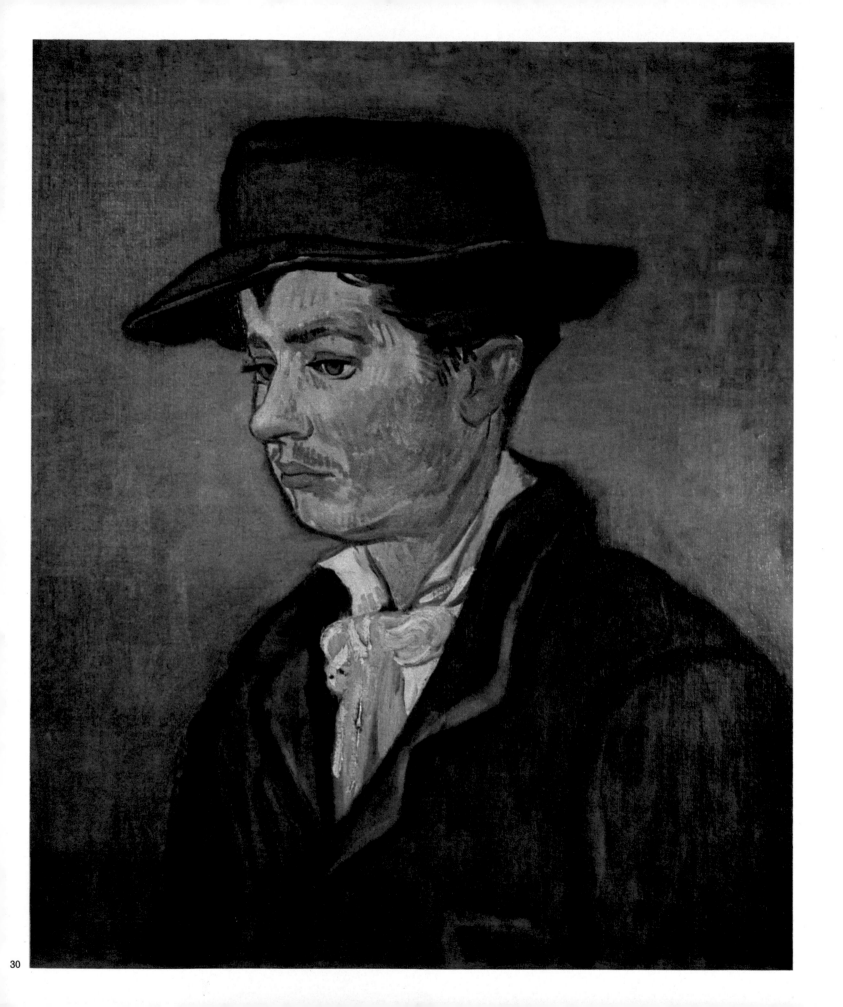

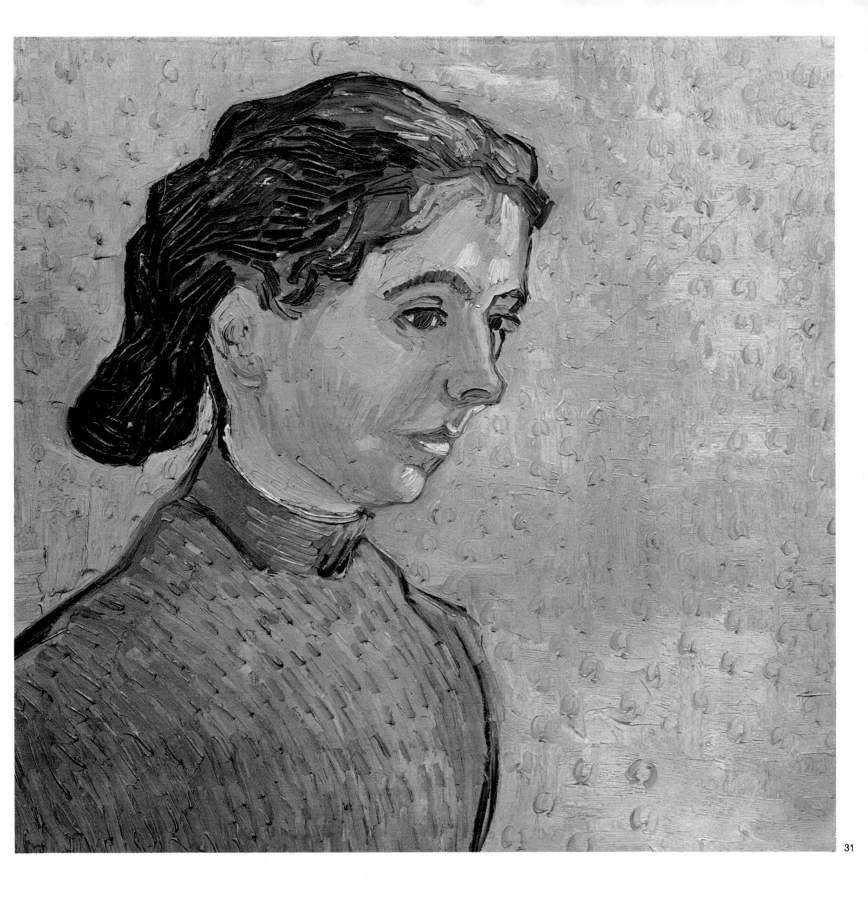

31

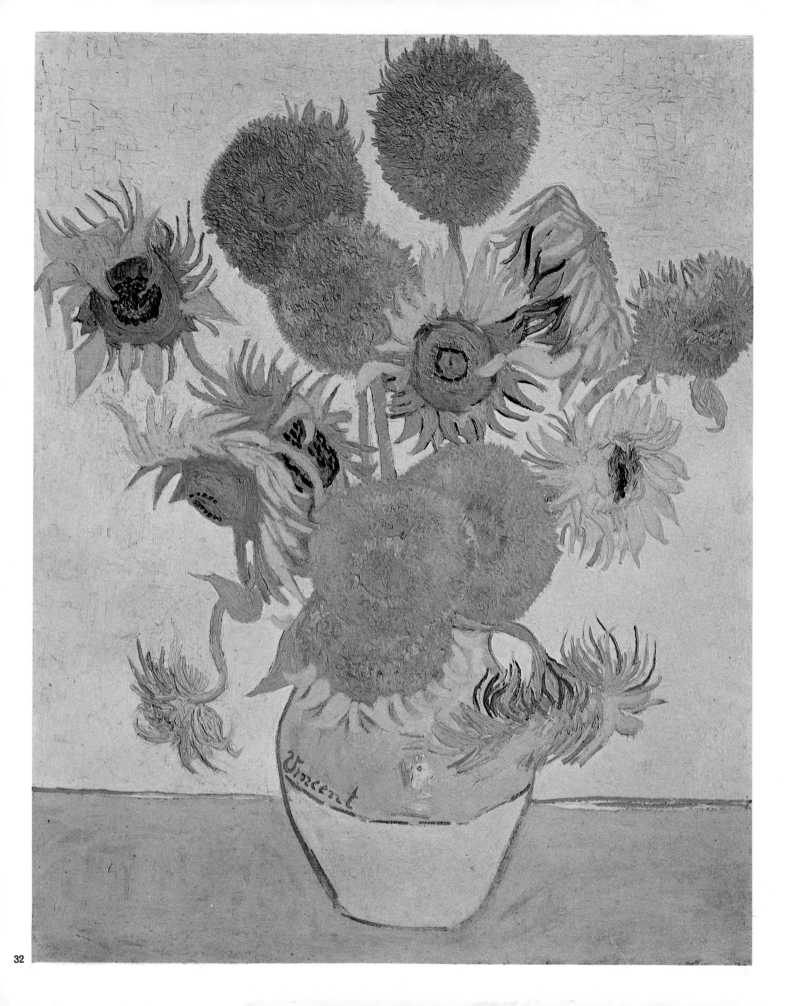

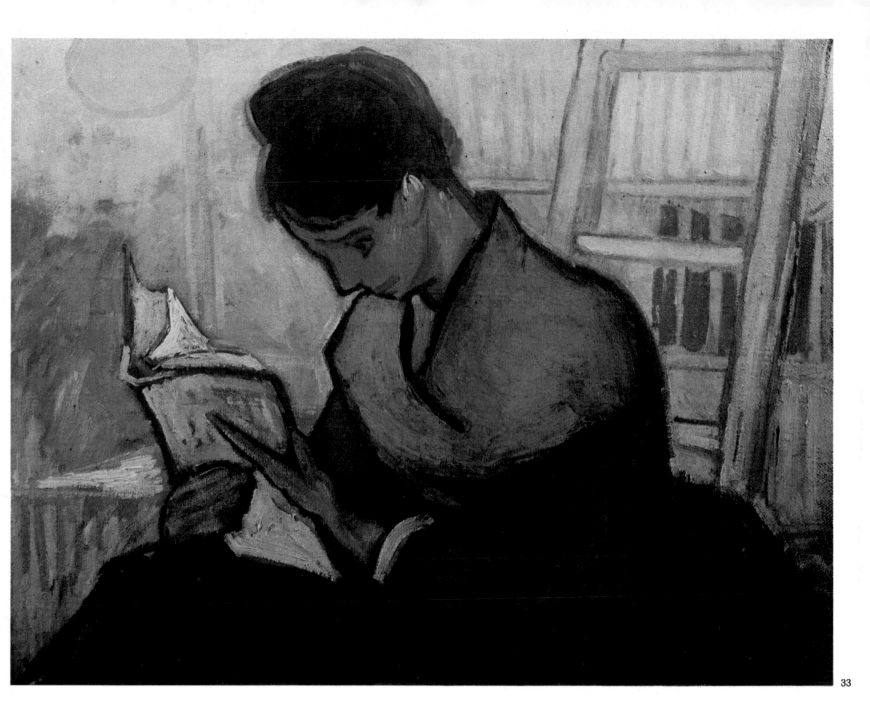

33

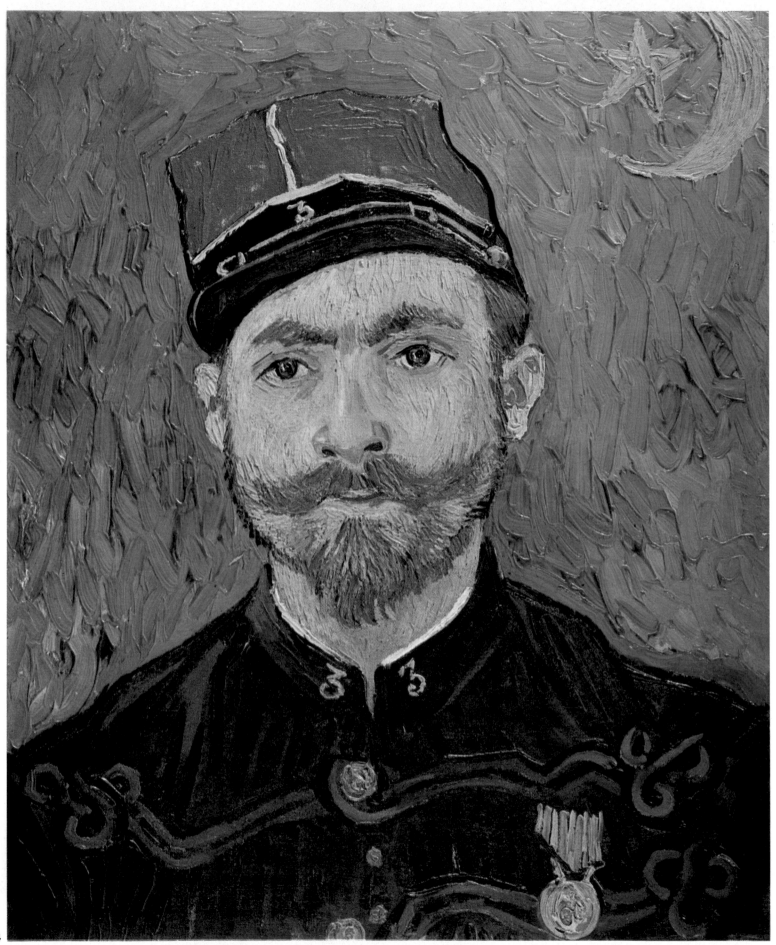

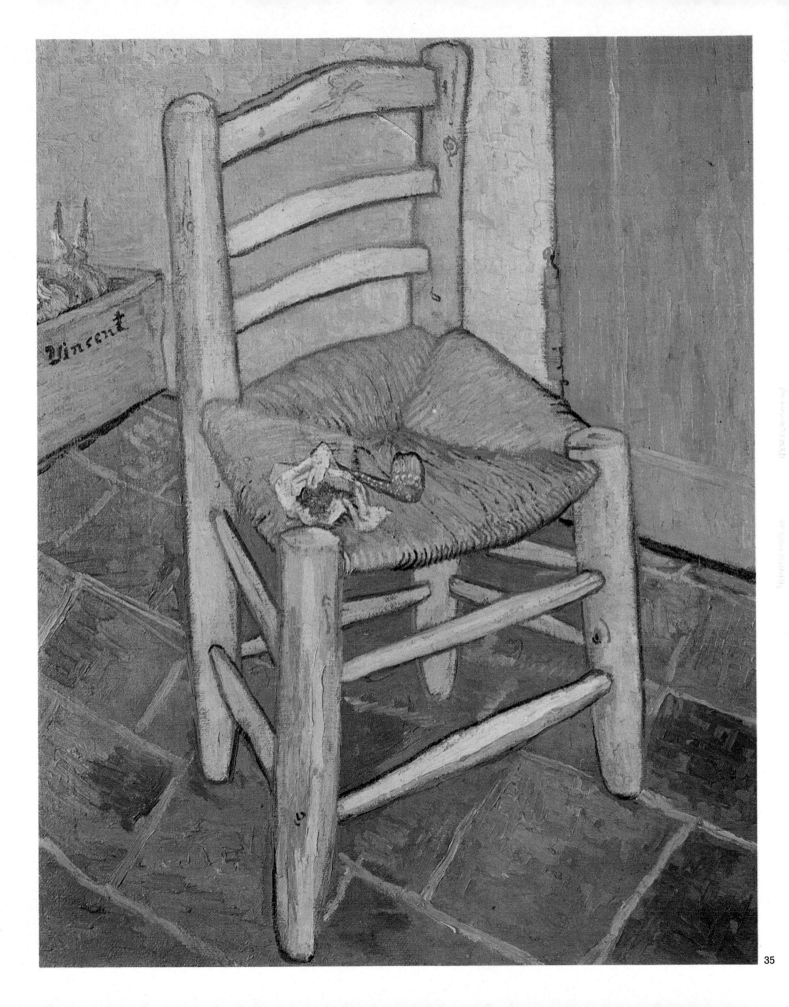

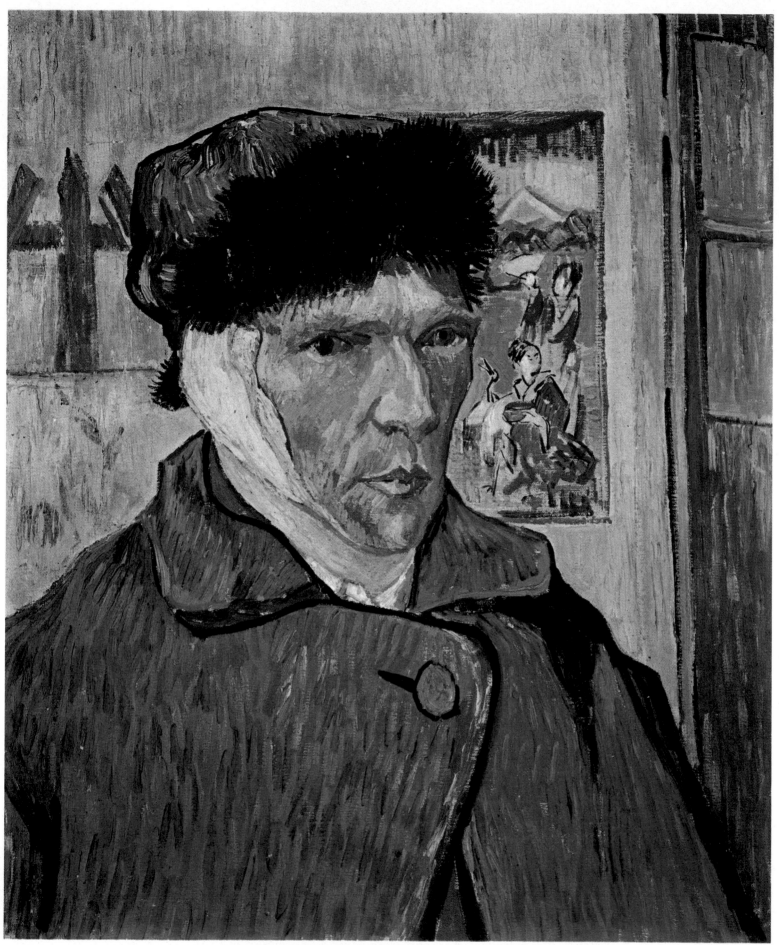

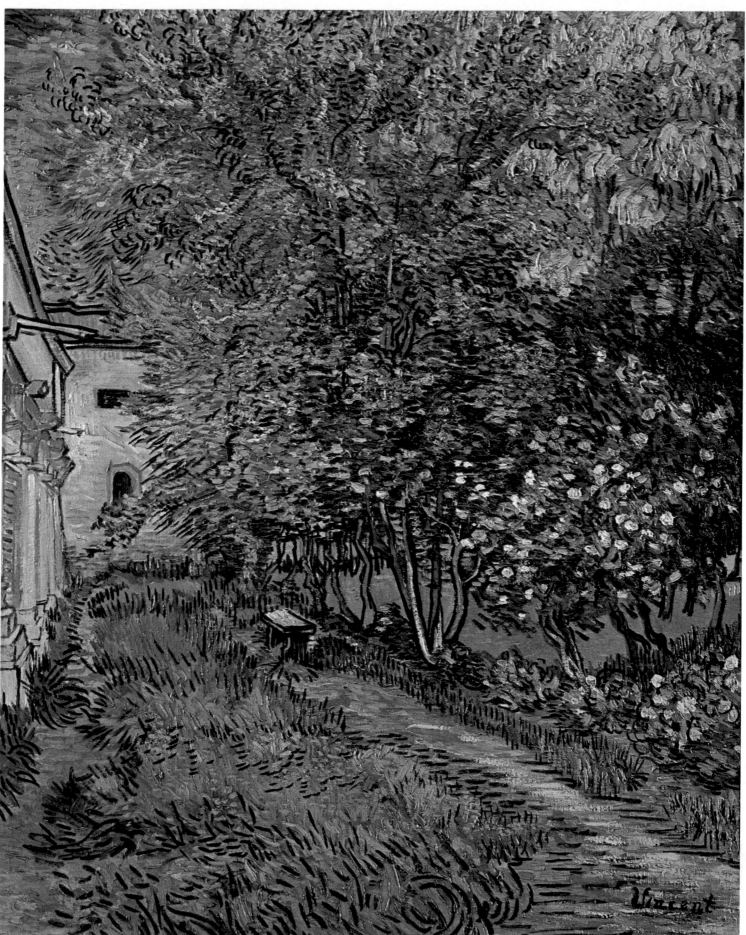

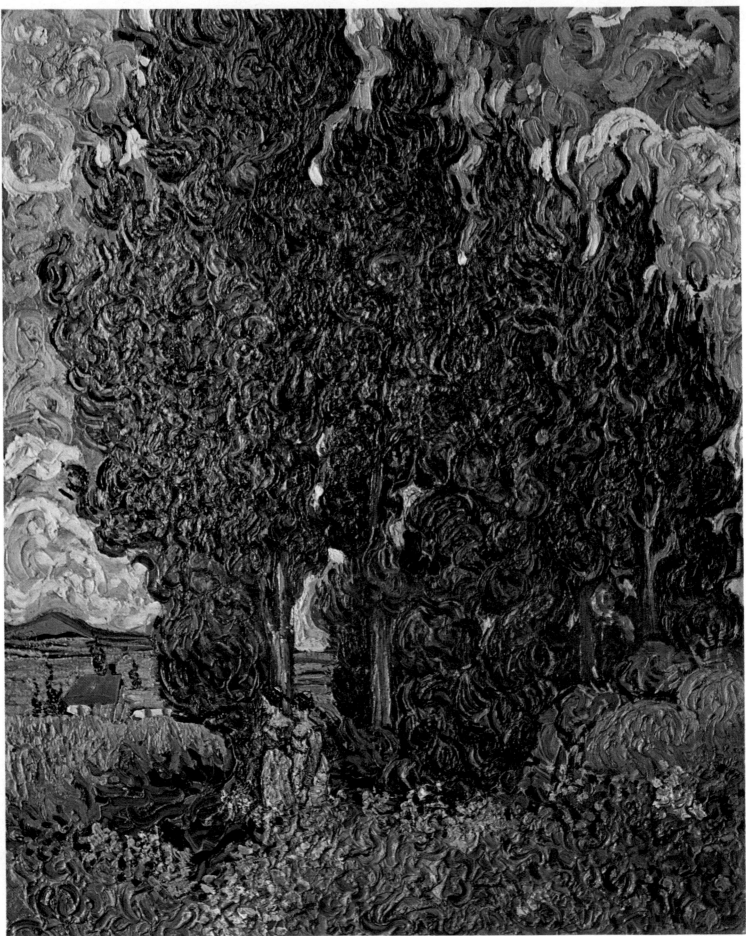

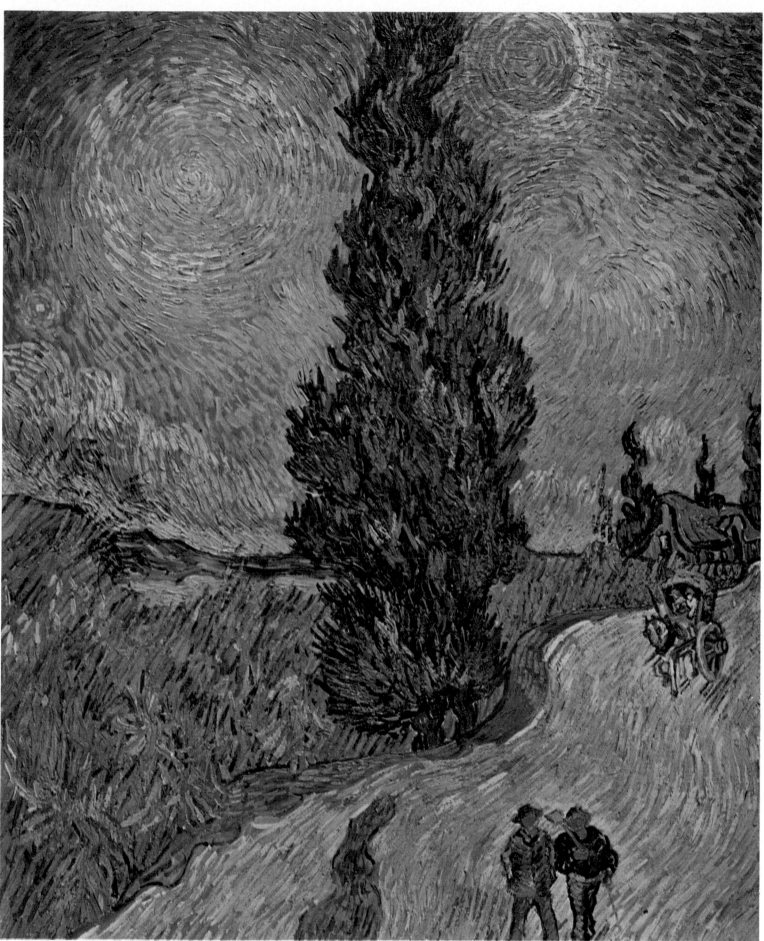

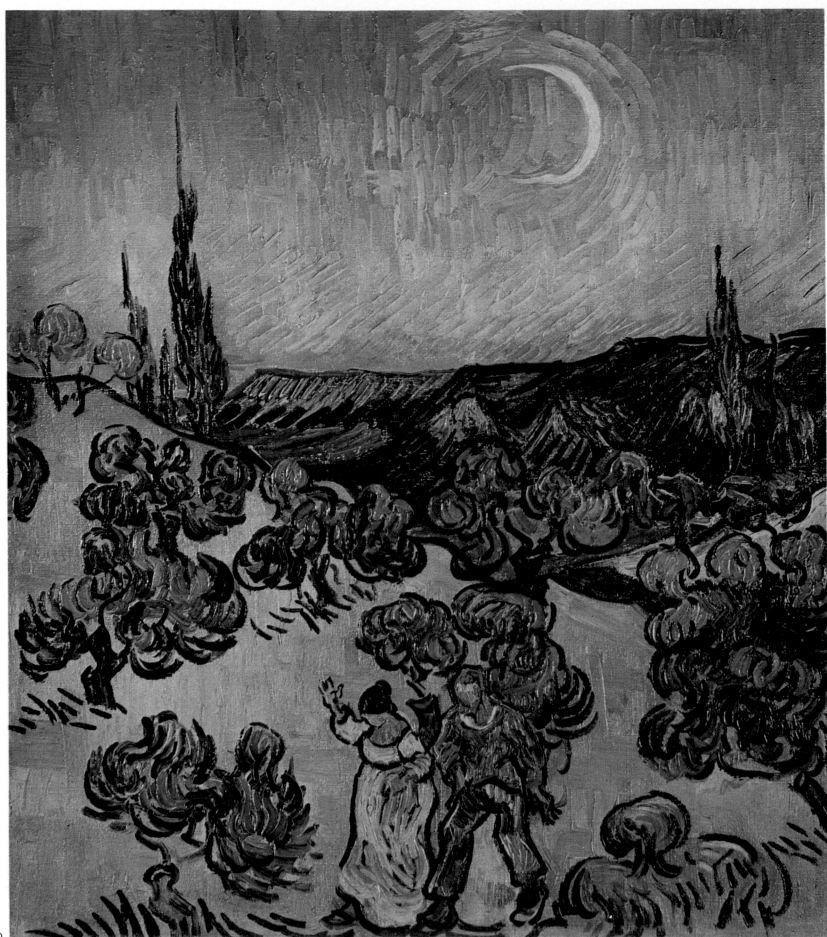

40

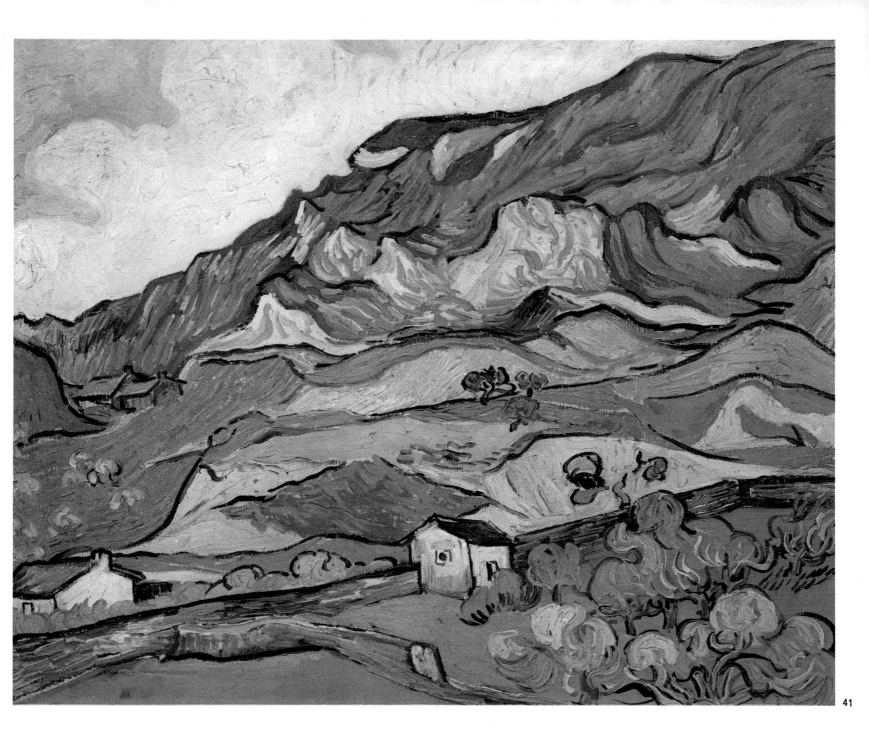

41

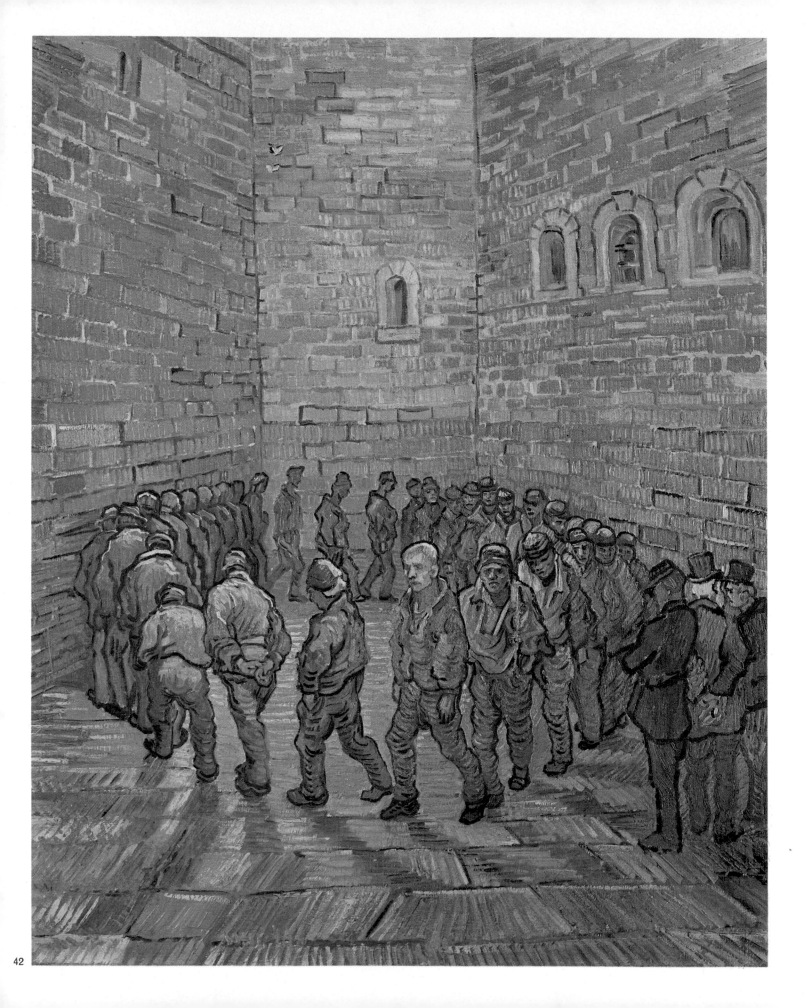

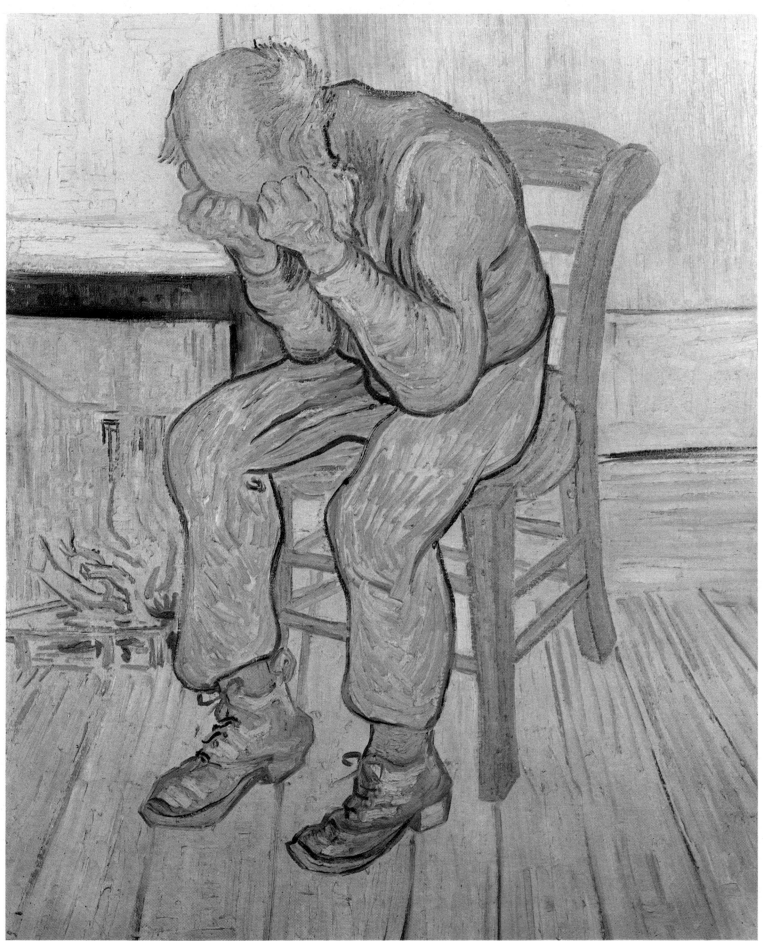

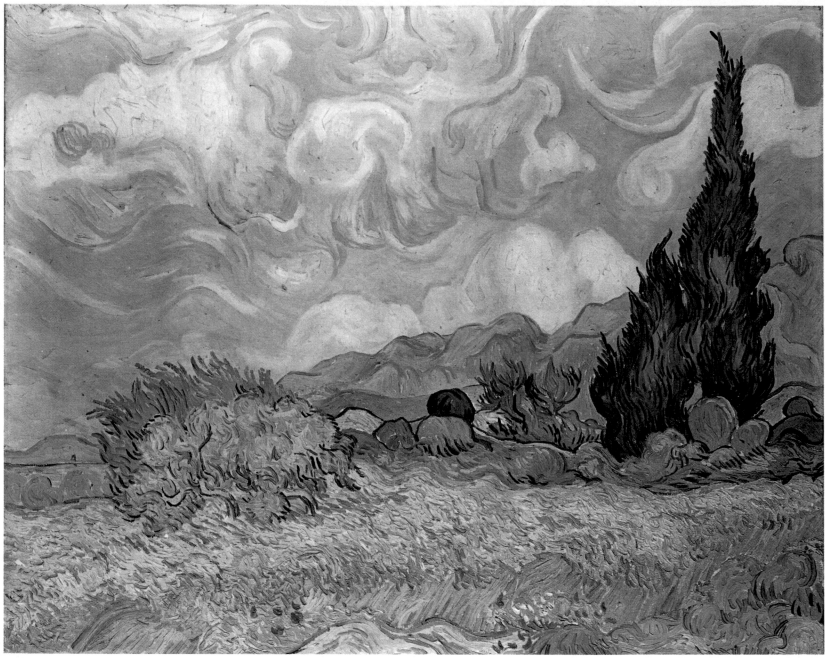

44

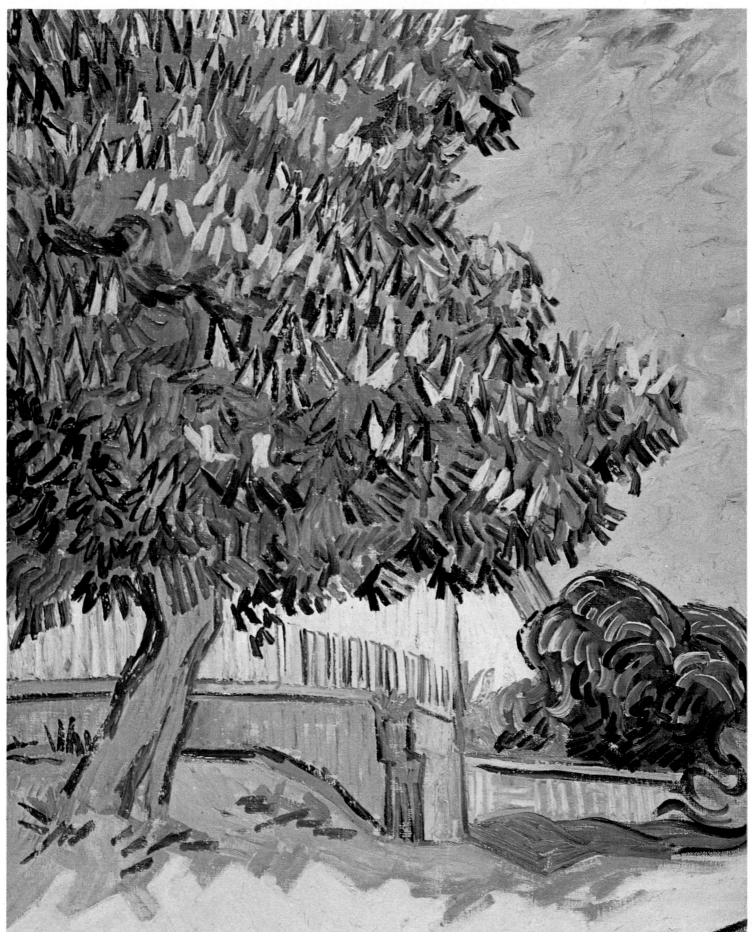

45

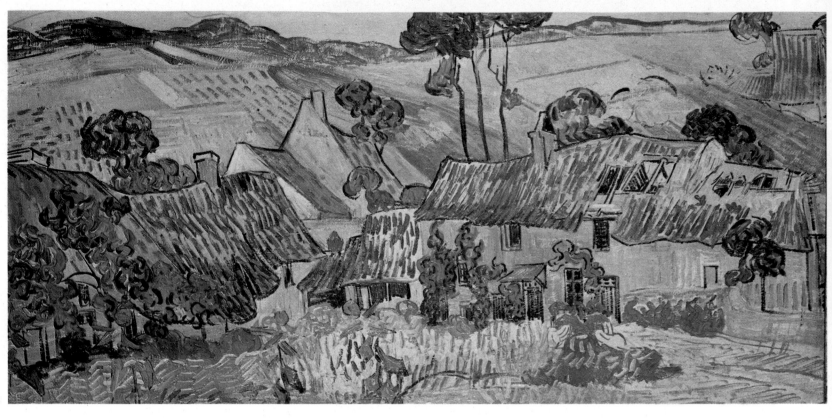

46

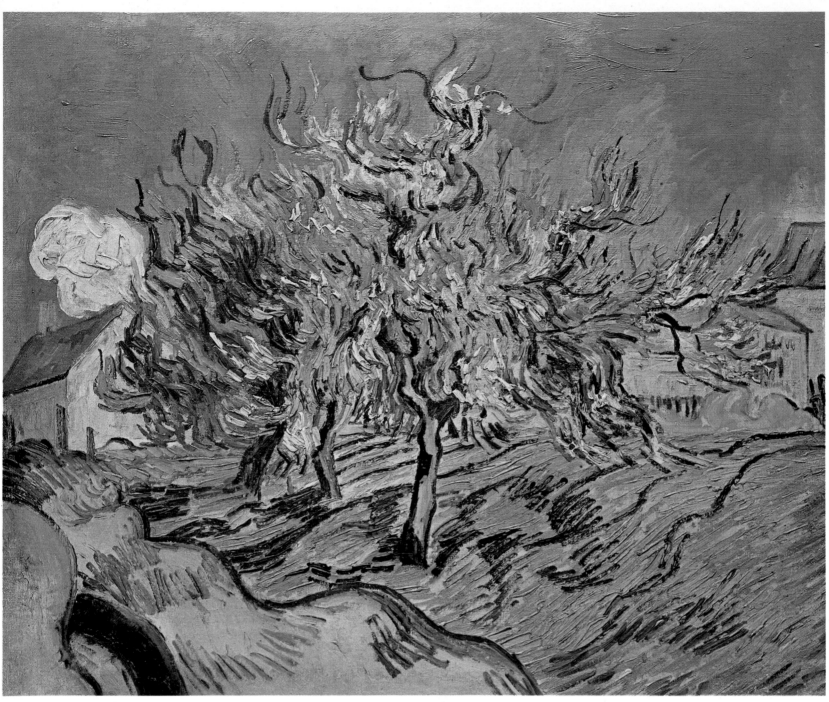

47

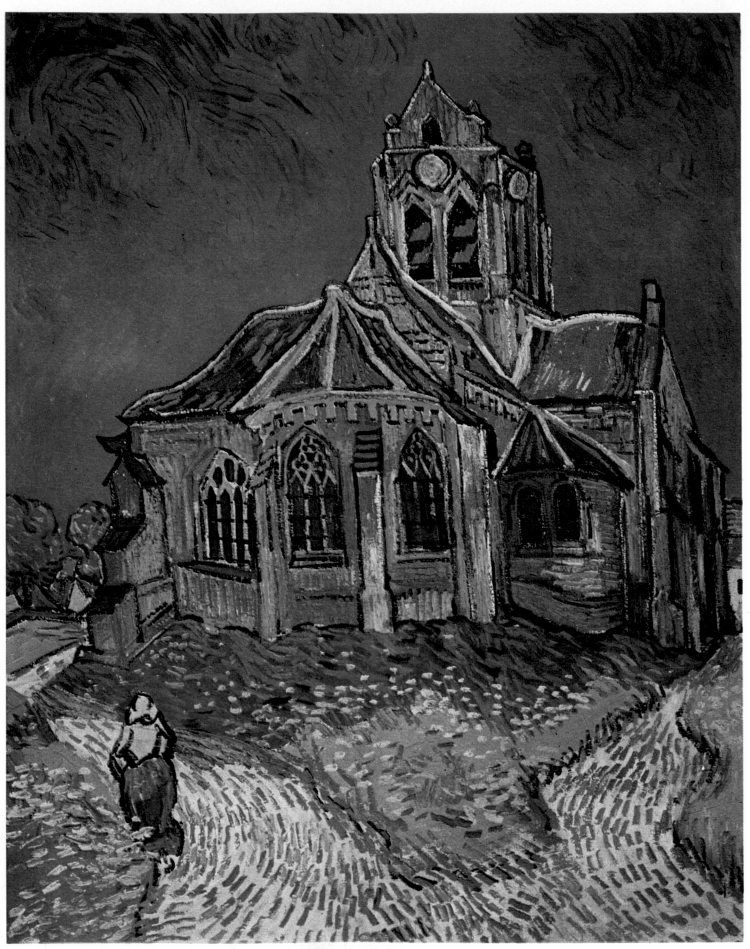